THE ART *of* MONEY

2846068578

THE ART *of* MONEY

THE HISTORY AND DESIGN OF PAPER CURRENCY
FROM AROUND THE WORLD

by David Standish
Photographs by Tony Armour Photography, Joshua Dunn

CHRONICLE BOOKS
SAN FRANCISCO

Text copyright © 2000 by David Standish.
Photography copyright © 2000 by Tony Armour.
All rights reserved. No part of this book may be reproduced in any form without written permission from the publisher.

Library of Congress Cataloging-in-Publication Data
Standish, David.
 The art of money: the history and design of paper currency from around the world / by David Standish; photography by Tony Armour.
 p. cm.
 ISBN 0-8118-2805-0
 Paper money—Case studies. I. Title.
 HG353 .S678 2000
 769.5'5—dc21 00-022726

Printed in Hong Kong.

Designed by Jeremy G. Stout
Composition by Suzanne Scott
Distributed in Canada by Raincoast Books
9050 Shaughnessy Street
Vancouver, British Columbia V6P 6E5

10 9 8 7 6 5 4 3 2 1

Chronicle Books LLC
85 Second Street
San Francisco, California 94105

www.chroniclebooks.com

ACKNOWLEDGMENTS

I would like to thank, first and foremost, ace photographer Joshua Dunn—not only for his terrific pictures, but for his beyond-the-call-of-duty enthusiasm for the project, and his invaluable help in the challenging (and sometimes maddening) process of tracking down the notes and coins that appear here.

Thanks, too, to Kathleen Burke of *Smithsonian* magazine, whose interest in the idea led to the article on which this book is based; to my agent, Noah Levin, who first saw its possibilities as a book; and to my patient, and sometimes long-suffering editor, Alan Rapp.

The cooperation and resources of several institutions were also crucial—and greatly appreciated. Thanks to Jeffrey Seibert of the Federal Reserve Bank of San Francisco, for letting us use examples from its extensive United States currency collection; to Louis Jordan of the Department of Special Collections at Notre Dame, for making available its colonial currency notes; and to Douglas Mudd of the National Museum of American History's Numismatic Collection, for the use of its rare notes as well.

This book also wouldn't exist without the assistance of several generous currency dealers, who let us photograph their beautiful—and often expensive!—bills without charge. Especially helpful was Jim Raye at Harlan J. Berk, Chicago, Illinois (www.harlanjberk.com). Thanks, too, to Anna & Tom Sluszkiewicz of ATS Notes, Burnaby, British Columbia (www.atsnotes.com); Audrius Tomonis of Mooreseville, North Carolina (www.banknotes.com); Lee Gordon (P.O. Box 5665, Buffalo Grove, Illinois, 60089); Lowell C. Horwedel of West Lafayette, Indiana (horwedel@concentric.net); and Steve Eyer of Mount Zion, Illinois (seyer@midwest.net). Pedro Gonzales at the Chicago branch of Thomas Cook provided considerable help in chasing down current bills from faraway places.

Finally, very special thanks to my children—Lisa, Maude, and Willie—for cheerfully putting up with my not ever producing much of the commodity in question, and to Mary Reiley, for her thoughtful ongoing interest and support.

TABLE *of* CONTENTS

INTRODUCTION

For years, as an American traveling abroad, I only thought about the local paper money in terms of how many—or how few—pounds, francs, kroner, yen, or pesos equalled one U.S. dollar. Even with a calculator I was usually too confused or flustered to pay much attention to what the money looked like. The images and designs simply didn't register. Compared to the solidly stolid U.S. bills that were everyday "real" money to me, most foreign notes seemed too colorful and cute. Knowing I'd be coming back to good old greenbacks, however dull-looking, foreign money was often hard to take seriously—beyond figuring out the exchange rate.

But that gradually changed. When I calmed down enough to begin looking carefully, I realized that, at the very least, some of these colorful notes are flat-out gorgeous. For instance, take the 50 guilden bill from the Netherlands in figure 1.

In the haphazard poll I took of people working at Thomas Cook Currency Services, which daily handles money from most of the world's countries, it was voted prettiest of all. There's a splendid asymmetry, and the golden sunflower with a bee nuzzling in it harks back to the precise and vivid painting done in the Netherlands during the Northern Renaissance, a tradition the Dutch are rightly proud of. In indirect but bright homage to van Gogh, the image says, simply by being placed on the bill, that they value art and beauty in the Netherlands.

What's on paper money says a lot about the country it comes from. Beyond the basic aesthetics, countries project their self-image through their money. What they decide to put on the bills reveals what's important to them—what they think is special and wonderful about themselves—and shows how they want to be seen by the world.

I first began noticing this on a trip to China some years ago. This was just after Nixon's first visit, and they'd come up with two separate currencies, one for local folks and one for the expected influx of tourists. The tourist bills were new and crisp, and looked like cigarette coupons from the 1950s. Engraved on the front were tranquil natural scenes (figure 2A), while the backs were occupied by instructions in English on their proper use (figure 2B).

The regular notes for everyone else were older issues, most of them worn and dingy, and emblazoned with images not from traditional Chinese landscape painting but of socialism on the march—happy workers bearing tools on one, a good citizen driving a tractor on another (figures 3A & 3B).

The dichotomy was glaring: China was supposed to be lovely waterfalls and

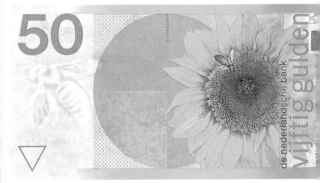

FIGURE 1

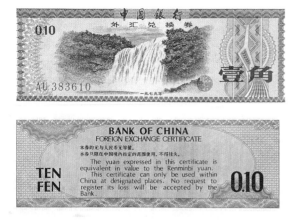

picturesque karst mountainscapes to us, but cheerful communal work to the Chinese.

The differences among money from certain Caribbean nations are another example of divergent messages. Many Caribbean currencies look like come-hither vacation brochures. The face of a recent Cayman Islands $1, for instance, bears a portrait of Queen Elizabeth II, which is staid enough, but to her left there's an open undersea pirate treasure chest filled with gold coins (a semi-liminal ad for Cayman banking practices?), while the back shows a coral reef scene of sea fans and serene tropical fish. These days the Bahamas have toned things down a bit, but in the late 1960s they not only had a $3 bill, which is hard enough to take seriously, it

unironically displayed the image (figure 4) on its back.

True beach money!

Similarly, the Eastern Caribbean Union tempts with a view of paradise (figure 5).

But then there's Jamaica among these vacation wonderlands. One of the appealing things about Jamaica, a country with a complex history, is that it doesn't present itself as little more than a beach. They don't downplay the hard parts, and you can see this on their money.

Their $2 bill, for example (figure 6).

True, a lovely emerald streamertail hummingbird is hovering next to the portrait, but the face on the bill is that of Paul Bogle. Who? Bogle was one of the leaders of the failed Morant Bay Rebellion of 1865—a bloody uprising by poverty-stricken ex-slaves in which eighteen whites were killed, including the chief magistrate of the parish. They didn't win. Martial law was declared, and the instigators executed, Bogle among them. The face on the $10 bill is George William Gordon's, the chief Morant Bay leader, who was also put to death by British authorities. That these men are commemorated today on Jamaican money says a great deal about Jamaican values, as do the backs of both bills. The

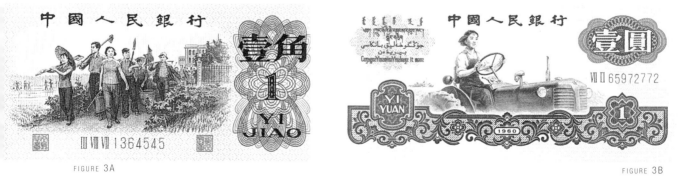

FIGURE 3A

FIGURE 3B

$2 bill shows a happy, racially mixed group of kids and the words "Out of many, one people." Commenting on this national motto, the *Encyclopaedia Britannica* says it "describes a multiracial society whose integration can be described as both profound and enviable"—an unusual touch of feeling in its generally dry accounts, and an accurate one. The reverse of the $10 bill is nearly as telling. Not palm trees or beaches or sweet cuddly creatures, but a bulldozer, earthmover, and crane, digging away, with a processing plant in the back (figure 7).

Why put a mining site on the money? Because the bauxite industry is very important to Jamaica's economy, as major a part as agriculture and tourism, which they announce through their money.

So there's a lot to be learned by taking a careful look at the images on world paper currencies. All of it is propaganda of a sort, if often in a more positive way than that word usually indicates. Perhaps better to say that it's a form of persuasion.

After looking at bills from practically every country producing them today, I found that certain visual themes emerge. Most commonly represented are Fearless Leaders, past and present. Since money is produced by governments, it's no surprise that politicians are up there at the top. Who's on the face of all the bills issued by Iraq at the time of this writing? Of course—Saddam Hussein. Putting who's in charge of the money is an expression of power—and it's a practice that goes back to the very beginnings of money itself. A concomitant is to put some dull building on the back—often the Treasury, or the King's Palace, or some other structure embodying governmental importance, a form of institutional narcissism.

Happily, many countries are more egalitarian. The people on their bills are, well, just people: representative figures, often seen doing something typical— fishing, farming, making baskets, playing

FIGURE 6

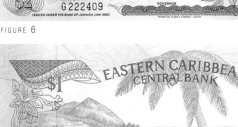

FIGURE 4

FIGURE 5

games, often simply smiling. Or they are local heroes, people who have done something important and noteworthy (other than run the country): artists, scientists, musicians, educators, athletes.

Paper money is a history lesson. Historical figures, real and mythological, crowd the bills. As do vignettes of major historical moments—major to the country in question, at any rate. Significant structures: Could there not be a pyramid or two on an Egyptian piastre? Machu Picchu on a Peruvian nuevo sole? French francs without a bill showing the Eiffel Tower? Or no archetypal yurt on the Mongolian tugruk?

I noticed a run on imagery relating to economics. The Jamaican bauxite bill is an anomaly on come-hither Caribbean money, true. But many bills celebrate The Romance of Industry in its myriad forms. I hadn't expected to encounter so many smokestacks and factories, mightily polluting away, shown on international currency as symbols of progress. Likewise vast modern construction projects, particularly hydroelectric dams, and airports, too. These are especially favored on the money of developing countries, to show how far they've come so quickly.

Crops and harvests are also common. If there's one machine that shows up most on world money, it's the prosaic tractor in many shapes and sizes. Common, too, is the gathering of all kinds of produce—coffee, sugarcane, wheat, corn, rice, whatever is an important export or staple. Environmentalists might wince, but a few tropical countries feature images of guys with chainsaws, logging their rainforests. But the North American timber industry is

still carving clearcuts in this continent's dwindling forests, too. And we tend to forget that all of England was once a forest, most of it cut down for firewood by the time of Queen Elizabeth I.

The International Zoo on world money is also great fun to look at. In terms of frequency, the favorites, far and away, are birds. No less than seventy-three currencies have birds on them, which is nearly a third of all the countries that produce their own money. These range from such obvious stunners as the resplendent quetzal (Guatemala), the bird-of-paradise (Papua New Guinea), and the red-billed toucan (Suriname), to the more commonplace, barn swallows (Estonia), seagulls (Finland), and geese (Sweden)—though perhaps the

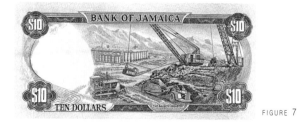

FIGURE 7

best is from Denmark, which gets my Avian Democracy Award for picturing, on its twenty kroner note, the humble, lowly house sparrow. The representation of other creatures is wide, and splendid. Almost every country with notable characteristic species shows them proudly, from the aardvark (Zambia) to the zebra (South Africa and others). And not only our warm-blooded friends. Sri Lanka, for example, has some gorgeous fish and lizards on its money; and even a few insects are given face-time, including some giant ants on Switzerland's current thousand franc note.

Less pleasant facts also reveal themselves. Runaway inflation, for instance. You can see the sad turmoil in the ever-escalating digits on the money of countries riding a wild economic roller coaster—Brazil, Peru, the former Yugoslavia, Croatia, and Bolivia, to name a few such unfortunates. Sometimes it gets so bad they just lop off six or seven zeroes, and/or change the name of the basic unit, and start all over again. The caliber of the art drops. Why go to the time and expense of making a really fine engraving when the bills may be on the bottom of birdcages in a matter of months? The quality of the paper zooms downward, too, for the same reason. Much of this hyperinflation money would look better if it were produced on a color Xerox machine. The one quite remarkable exception to this general tendency was the *notgeld* produced in Germany during the twenties, in response to its deep postwar depression and mind-boggling inflation. There the demands of inflation led to an efflorescence of artistic creativity unique in the history of paper money.

Counterfeiting has been paper money's evil twin forever. It probably came along about three days after the first real bills began circulating. Its looming presence has had a major effect on paper money, and has forced legal producers to keep inventing new, improved techniques to foil counterfeiters. In American colonial times, money designers such as Ben Franklin put little hidden bleeps and blips into the images; today, a whole arsenal of techno-wizardry has been brought to bear against these naggingly persistent crooks. Watermarked paper, in use over five hundred years, has been made even trickier; secret threads, holographic windows, special inks—the devices are myriad. Even a casual look shows that the design of modern bills has been made incredibly complex, so much so that the backgrounds on many look like Op Art exercises from the sixties—truly wild and crazy. So we have counterfeiters to thank in part for the bold, abstract designs common today, as well as all the sneaky little details hidden here and there.

As I've said, there's a lot to be learned from these bills we hardly notice while using them. Yet these quirky, individualized currencies seem to be becoming something of a vanishing species. When the Euro comes fully on line in 2002, it will wipe out a handful of lovely, idiosyncratic currencies that began to evolve centuries ago. In their place will come bills whose images are generically European—which is to say, far more bland-looking than those they've replaced. Two South American countries, Ecuador and Argentina, have recently been considering the replacement of their own currencies with the American dollar. Further, more and more people use credit cards to buy things these days. The trend toward "electronic money" grows every day. And new pseudo-currencies such as "airline miles" are popping up. Highly individualized paper money may in fact be gradually on its way out.

So before it's over, let's go back to the beginning.

A SHORT HISTORY OF MONEY

Before money, of course, there was barter. You're a member of an ancient society, a fisherman, but you're sick of eating nothing but fish all the time. Somebody else is a hunter, and he's just as tired of rabbit and deer. You agree on a trade, so many fish for so many rabbits. Simple. But say you need some shoes, or a nice new deerskin coat because winter's coming, and the guy who makes them hates fish and simply isn't interested. What do you do?

Early societies solved this problem by developing a form of proto-money—the use of commodities of various kinds as currency. Something that everybody agrees will be accepted in trade. And at various times and places, virtually anything you can think of—and some you wouldn't—has been used.

Aztecs paid their debts in cacao beans, valuable to them but seemingly useless at first to European invaders, who in one recorded instance captured a boatload of them and dumped it all, mistaking the cargo for a load of rabbit scat. Until the mid-1960s the islanders of Yap used rocks—some of them weighing several hundred pounds. Glyn Davies, in his exhaustive 800-page *A History of Money*, mentions, in part, amber, beads, drums, eggs, gongs, hoes, ivory, jade, kettles, leather, mats, nails, quartz, thimbles, vodka, yarns, and *zappozats* (decorated axes). Norwegians once used butter and codfish. On the Admiralty Islands, it was dog's teeth; boar tusks in New Guinea; whale's teeth on Fiji; snails in Paraguay; feathers on the Santa Cruz Islands. And, my own favorite, on the sad little island of Nauru in the western Pacific, rats. I don't like to picture their business transactions.

The most universal early commodity-currencies were crops, cattle and other animals (and/or their skins), and metals, their use so widespread and enduring that many of today's money-related words trace their roots back to them. *Pecuniary*, for instance. My old *Webster's Collegiate* defines it as "consisting of or relating to money," derived "from the Latin *pecuniarius*, from *pecunia*, money, orig. property in cattle, from *pecus*, cattle." *Capital*, *cattle*, and *chattel*—since human slaves have also had an unfortunate continuing vogue as currency—also come from the same root. The word *salary* is another that goes back to pre-cash days. *Webster's* again: "from Latin *salarium*, pension, stipend, orig. salt money"—which is what early Roman soldiers were paid, since salt was both necessary for living and relatively hard to come by. Need to borrow five *bucks*? That one's an Americanism, going back to the time in North America when deerskins were used as money.

These commodity-currencies were things that were useful in and of themselves, and a step beyond barter—a generalization of that idea. But some of the stuff in the list above manifestly was *not* utilitarian. The rocks and teeth represent a major leap in our long cultural evolution: a shift to using as *ur*-money objects that are only *symbolic* of value. Sad perhaps to say, but money is one of the things that defines us as human.

It was an invention, an intellectual concept, one that no other species has created—or, it should be added, has ever felt the need for.

One of these early symbolic currencies, which endured for centuries, was also one of the first instances of money as aesthetic object or ornament—cowrie shells. Their main source was the Maldive Islands off southern India, from which their use spread worldwide, continuing in parts of Africa until recent times.

Cowries were collected, cleaned, and strung on thongs. They were terrific money since they could be counted easily, couldn't be counterfeited, and had the additional plus of being highly decorative—you could wear necklaces of your fortune to parties if you felt like it. In fact it seems likely that cowries were valued first because of their aesthetic and talismanic properties, and then evolved into a currency. Common as seabirds on the Maldive beaches, their value increased dramatically the farther they got from the source and the scarcer they became.

They came into widespread use as a currency in China during the Shang Dynasty (1700–1100 B.C.), an innovative Bronze Age culture that invented Chinese writing. Cowries were so significant for so long that the written character for "money" in Chinese today is a stylized pictographic representation of the shell.

One North American version of shell money was wampum. It was made from oblong clamshells that were sawed into beads, polished, and then strung on leather or sinew strings.

It may be hard to imagine today that clamshells on strings could be so desirable, but this was such a handy and successful currency that wampum remained in use on the North American frontier until late in the nineteenth century. The chronically cash-starved American colonies couldn't have gotten along without it as a medium of exchange, and in several it was designated as legal tender. A wampum factory established in New Jersey in 1760 stayed in business until a year before the Civil War. Paying for things with wampum is where the phrase *shelling out* comes from. Like regular money, even wampum suffered from inflation. Until 1680 or thereabouts the hole in each shell was individually drilled using tools not far advanced from the Stone Age. The task required skilled workers and was fairly time-consuming. But then steel drills were introduced from Europe. Practically anybody could make the stuff, and do it faster. Output soared. There was more and more wampum in circulation, and value correspondingly dropped. Not even a clamshell currency was safe from the onslaught of technology.

The first money that was more than incidentally artistic came with the invention of coins in Lydia—in present-day Turkey— around 600 B.C. The Lydians were a society of seagoing traders, and they were probably inspired to think of coins—truly an imaginative leap from corn or wheat or slaves, or any other commodity-money—in order to have a more universal trading currency, and thereby do more business with more people of considerably varying persuasions. Since precious metals were among the most desired commodity-moneys world-wide—most societies seem to love silver and gold—the Lydians' translation of this widespread appreciation to coins made

brilliant sense. Coins not only had an intrinsic value as metal, they were easily portable, and durable as well.

The earliest Lydian coins were made from electrum, a natural mixture of silver and gold, and weren't much more than oval lumps with a rough identifying mark stamped into them (figure 1). They were tiny—a little smaller than a U.S. dime. But by the time of King Croesus (c. 560–546 B.C.) the Lydians had developed separate silver and gold coins with recognizable images (figure 2).

Their not-so-friendly neighbors the Greeks quickly picked up on the idea— although the historian Herodotus (c. 484– 420 B.C.) wasn't convinced. He disdained the Lydians' mercantile ways, putting them down for inventing coins, and opening the first permanent stores, as well as for their occasional custom of making a little extra income by selling their daughters as prostitutes. Call him a purist.

Lydian and Greek coins established a number of artistic motifs, with cultural resonance, still evident on money today. The earliest images were symbolic logos representative of the various city-states producing them.

Croesus's coins were imprinted, on one side only, with faceoff heads of a lion and a bull. This was doubtless to suggest how tough he was. During his reign, Croesus conquered the Greeks on mainland Ionia, and became the mega-wealthy Bill Gates of his time. Twenty-five hundred years later, "rich as Croesus" is still a common expression. But his kingdom was knocked off by Persians led by Cyrus, and Croesus proved to be the last king of Lydia.

Images from the animal kingdom, both real and mythological, predominated on early coins—and remain a favorite on paper money today.

One of the early Greek coins featured a turtle (figure 3), emblematic of Aphrodite,

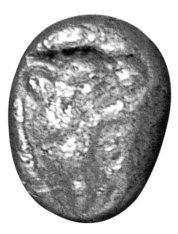

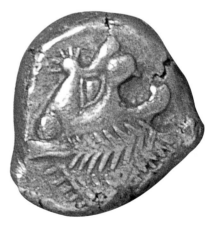

FIGURES 1 & 2

possibly alluding to her birth from the sea. She sprang to life out of the foam from the splash when Uranus's testicles (cut off and dropped by his son Cronus) hit the water—one more genteel Greek myth. Among the most widespread coins in the ancient world were the "owls" produced by Athens, with the city's namesake goddess on the face, and the wise bird symbolizing her on the back (figures 4A & 4B).

Eagles, doves, bees, goats, and roosters were represented on Greek coins, along with various mythological beings and/or deities associated with the city-states producing them—among them Pegasus (the winged horse that used to fly on Texaco signs), the Minotaur, and Dionysus (figure 5).

Most of these creatures were suggestive of power, of course. Bulls and lions were the most common animals represented. The message of a coin showing a lion fleeing from a chariot was clear. Yet more out front was one from Syracuse depicting Heracles's legendary feat of strangling a lion. The ancient city adopted the myth as a metaphor for *Don't mess with us!* Right from the start, the images on money were a form of propaganda.

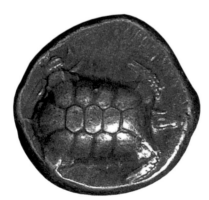

FIGURE 3

At first this visual ploy was indirect, showing political power by association. Initially the honchos running things in these various city-states didn't have the temerity to put themselves on the coins, so they used images that already suggested strength and authority, usually gods and goddesses, and/or powerful animals, real or imagined. But that changed pretty quickly. Hubris kicked in, and the face on the coinage was that of the current leader. Such is still the case on many of the world's currencies.

The coins issued by Philip II of Macedonia, who ruled between 359 and 336 B.C. and conquered Greece toward the end of his reign, are a telling transitional instance. His face doesn't appear on the coins, but his name is on them, and one issue celebrated his winning of the chariot race in the 356 B.C. Olympic games on one side, with a portrait of Zeus on the other. That many people using these coins thought that Zeus was Philip himself didn't hurt. Philip was assassinated at the wedding of his son, Alexander, then twenty, soon to be known as Alexander the Great, who went on to conquer just about everything. His many victories were due in part to the huge supply of coins he had in his treasury to pay his armies and keep them loyal. At the greatest extent of his empire, it's estimated that he was paying out around one thousand pounds of silver a day.

Following his father's lead, Alexander put a head of Heracles on his coins, a Heracles that, no doubt by accident, looked a lot like Alexander himself.

The first leader to put his own face on his coinage was Ptolemy I of Egypt in

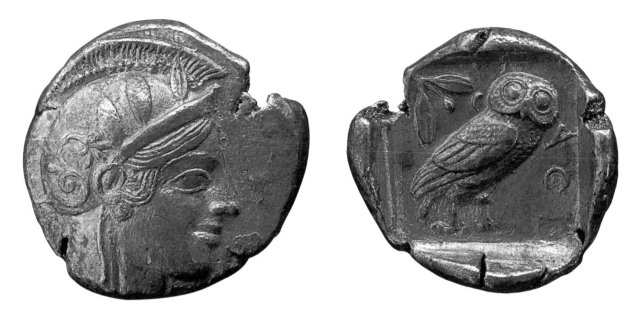

FIGURE 5

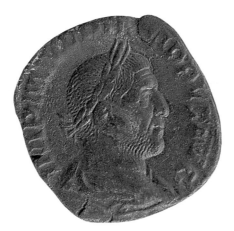
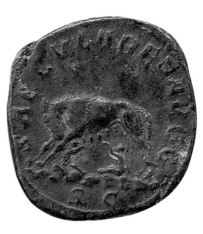

306 B.C. But then he had already declared himself a living god, so technically it wasn't that much of a stretch. This trend continued (and continues), reaching an apogee of sorts in Rome when Julius Caesar, one of the all-time egomaniacs, struck a coin with his portrait on the obverse and this boast on the back: DICT PERPETVO—or, DICTATOR FOREVER. The coin appeared in 44 B.C., the same year Caesar was stabbed to death by republican conspirators led by Brutus—so much for big plans.

Naturally Brutus in turn struck a coin with his own profile on it—and put two daggers on the back as a reminder of what happened to his enemies.

Roman coins further established another ongoing tradition in money—the commemoration of significant events in the empire's history: victorious battles, peace established, important births, imperial travels, major public events, acts of social reform, religious and civil anniversaries. Issued to celebrate Rome's millennium, figures 6A and 6B, respectively, show a coin with Philip I on the face and a she-wolf standing on rocky ground suckling Romulus and Remus, Rome's legendary founders, on the reverse.

Roman leaders even put their relatives on the coins. Hadrian showed an uncharacteristic charity toward mothers-in-law by putting his, Diva Matildia, on one—with a more traditional eagle on the back (figures 7A & 7B). One of the sweetest, from around A.D. 350, celebrated Rome's (legendary) eleven hundredth birthday. It pictured Emperor Constantine II on the face, a Roman soldier spearing a Persian on the back, and proclaimed FEL TEMP REPARATO, which translates as "Happy Days Are Here Again!"

As money historian Glyn Davies put it, "For over 500 years the coins of Rome publically portrayed the events, hopes, ambitions, lives and lies, of its rulers."

From Rome, too, we get the word *money* itself. As legend has it, the barbaric Gauls were swarming over Rome around 390 B.C. The temple of Juno, sitting atop the Arx, was not only a religious center, it doubled as a sort of Roman Ft. Knox, a

secure place where significant stores of coins were kept—and it later became the Roman mint. What would have been an overwhelming sneak attack was averted by the geese sacred to Juno that hung around the Capitol (like all those sedentary Canada geese that annoy golfers today). As the barbarians were launching their assault, the geese took flight, making such a honking racket that the defenders were warned and managed to hold off the Frenchmen-to-be. The thankful Romans constructed a temple afterward dedicated to Juno Moneta—Juno the Warner—for protecting their stash, and it's been *money* ever since.

By late Roman times the art on coins had become truly splendid. But coins are still coins—small round things. Hard for an artist to really wail on such a limited canvas. It was with the evolution of paper currency that the art of money truly took off.

As in so many other things, the Chinese came up with the idea first, around A.D. 810, though its influence on developments in the west was negligible.

They'd had the idea, but hadn't quite gotten it right, as early as 100 B.C., when a shortage of *cash*—as early base-metal Chinese coinage was known—led to the issue of high-denomination leather money with colored borders, made from deerskins square cut a foot long and wide.

Leather money, crude and cumbersome as it may seem, represented a noticeable leap of faith—however forced. Think about somebody handing you a square foot of deerskin and insisting it's worth $40,000. Incredulity would be your first response. This leather money required *belief* on the part of its users—foisted on them by the all-powerful Emperor. Getting people to accept a novel—not to say wacky—notion like leather money was easier for a totalitarian society like China's was at the time. The experiment with such money didn't last. A thousand years passed before the Chinese tried it again, this time with paper. None of the earliest examples survive, so we don't know what the money looked like. We do know that it

established an unfortunate precedent regarding paper money that's recurred periodically ever since—its close dual associations with war and hyperinflation.

Unlike coinage, which requires actual precious metals with an intrinsic worth, paper is cheap; and printing's so easy, the temptation simply to churn the stuff out has proved hard to resist. Paper money continues to have a siren song appeal as a seemingly painless quick fix in countries that find themselves struggling economically—even though Gresham's law that bad money drives out good has proved true every time. Over and over again, for centuries, all over the world, countries have printed too much, and the stuff quickly becomes worthless—and it's not even big enough to wrap fish in.

The Chinese were suffering a coin shortage when they first resorted to paper money early in the ninth century A.D. Much of their actual *cash* was leaving the country, some in an unbalance of trade as outgoing payment for considerable imports, and even more in the form of tributes paid to placate their threatening Mongol neighbors to the north, to keep them from invading—just like the payment of *danegeld* by England to the Vikings at about the same time, to encourage them to keep their hands off the sceptered isle. In both cases it didn't work. (Our word *pay*, not so coincidentally, derives from the Latin *pacare*, which means "to pacify.")

China's increasingly addictive reliance on paper money—having a face value of nearly three million ounces of silver by the year 1020 or so—led to the world's first hyperinflation. By 1166 the theoretical value of the paper money floating around was over forty million silver ounces. But in fact it was, well, not worth the paper it was printed on. Despite the harsh penalties for *not* accepting it as currency, people were understandably reluctant to do so. At one point, according to historian L. C. Goodrich, "a perfumed mixture of silk and paper was even resorted to, to give the money wider appeal, but to no avail; inflation and depreciation followed to an extent rivalling conditions in Germany and Russia after the First World War."

Still, when Genghis Khan successfully conquered China early in the thirteenth century, he found its paper money such a useful device for imposing a uniform currency on his vast Mongol empire that he continued its use despite the inherent dangers. He, too, made rejecting it practically a capital offense, and further encouraged its use by seizing everyone's silver and gold, giving back crisp new paper bills in return. This gave the government a monopoly on precious metals, leaving people with no other legal recourse but to use the the paper.

Word of this marvel first reached Europe in Marco Polo's *Travels*, which began appearing around 1304. He wrote:

"In this city of Kanbalu is the mint of the grand Khan, who may truly be said to possess the secret of the alchemists, as he has the art of producing paper money.... The coinage of this paper money is authenticated with as much form and ceremony as if it were actually pure gold or silver... and the act of counterfeiting is punished as a capital offense. When thus coined in large quantities, this paper currency is circulated in every part of the

grand Khan's dominions, nor does any person, at the peril of his life, refuse to accept it in payment ... All his subjects receive it without hesitation, because, wherever their business may call them, they can dispose of it again in the purchase of merchandise they may have occasion for ... With it, in short, every article may be procured ... All his majesty's armies are paid with this currency, which is to them of the same value as if it were gold or silver. Upon these grounds, it may certainly be affirmed that the grand Khan has a more extensive command of treasure than any other sovereign in the universe."

That the Chinese were the first to try the innovation of paper money makes sense, since they invented both paper and printing.

The Egyptians had developed the earliest form of paper in the fourth millennium B.C., but their *papyrus*, from which we get our word, was a lot cruder than true pulp-based paper. It consisted of long fibers from a tall aquatic grasslike plant that were woven into a mat. The resulting sheet was moistened, pressed—hammered, actually—and then dried in the sun. Papyrus was a nice bright white and terrific for writing on, but it was far too delicate to be used as money, had the Egyptians had the idea, which they didn't.

Paper's invention in China is usually ascribed to Ts'ai Lun, and the traditional date is A.D. 105. He was a courtier to the Emperor, and a eunuch, so he may have had nothing better to do than think about such abstruse things. An anonymous Chinese account describes the papermaking

process, which sounds fairly messy:

"[He] first made paper by pulping fishing nets and rags. Later, he used the fibres of plants; any which proved sufficiently elastic in tension were used as the raw materials for paper. The raw materials were first well boiled [can't you just *smell* those old fishing nets?] and then beaten into a mash. They were then stirred into a pulp and spread on a straining frame or basket. When it had formed a thin tissue, the resultant paper was then pressed with heavy weights."

One plant that proved especially successful in Chinese papermaking was hemp, that versatile weed. The quality of this early paper was high. The British Museum has examples going back centuries that are right up there with today's best hand-made rag papers, which are still made by much the same technique.

Paper was considered a miracle of sorts. Ts'ai Lun was deified for first creating it (though recent research suggests that he may have simply improved on ideas going back two centuries earlier). The paper-making process was a carefully guarded state secret. For the next 500 years, only the Chinese knew how to make paper. The technology spread east to Korea and Japan in the seventh century, but took considerably longer to get to Europe. An important step in this course was an accident of war. Some Chinese artisans were captured by Arabs at Samarkand in 750 or thereabouts. On learning that they knew the secret of papermaking, the Arabs forced the Chinese to do the same for them. From there, knowledge of paper-making gradually spread throughout the

Arab world, travelling from Samarkand to Baghdad in 793, to Damascus and Egypt in the tenth century, to Morocco by 1100. The first papermill in Europe was established by Moors on the Iberian peninsula in 1151, but the idea stalled there because of religious prejudice, of all unlikely things. Because heathen Arabs had introduced it, paper was frowned upon by official Christendom, and its use or manufacture discouraged. In 1221, Holy Roman Emperor Frederick II decreed that any official documents written on paper weren't valid— only parchment and vellum, made from calf, goat, or sheepskin, would do. Nevertheless papermaking was established in Italy by the end of the thirteenth century, and in France and Germany during the next.

One pretty basic reason, then, that paper money was such a late development in Europe was that they didn't have paper. Its arrival roughly coincided with the development in the fifteenth century of another world-changing innovation—the printing press.

The Chinese had developed printing in the second century A.D. a few decades after the invention of paper. They'd also invented ink, 2500 years earlier. The combination, with surfaces carved in relief (usually from wood blocks), dipped in ink, and stamped on paper, added yet another first to China's long list.

Moveable type—an essential component of printing with a press—was a Chinese inspiration as well, attributed to an eleventh-century alchemist. In 1313 a government official named Wang Chen set craftsmen to work carving upwards of sixty thousand individual characters on moveable woodblocks, with which he produced the world's first printed book—not poetry or the gnomic sayings of Buddha, but a dry treatise on the history of technology. From a typographer's point of view, Chinese, requiring thousands of different characters, is a nightmare, and Wang Chen's innovation wasn't widely pursued.

But twenty-six letters of an alphabet, and a sprinkling of punctuation marks, are another story entirely. Even including capital letters, italics, and boldface, all it takes is a few hundred pieces of moveable type and you're in business—once you have the *idea*.

The Chinese experiment remained unknown in Europe. Johannes Gutenberg was the first European to think of moveable type, and of how books might be more easily produced in greater numbers using it. Until then, all books and manuscripts were laboriously hand-copied. Outside the church, only the rich could afford to assemble even a small library.

The earliest notable western book printed on a press using moveable type, of course, was Gutenberg's Bible, which appeared in 1455. His glorious Bible doesn't bear his name because Gutenberg had borrowed money to get his idea going and was unable to meet the terms of the loan, so his banker partner foreclosed just before Gutenberg was ready to publish, and turned the operation over to his son-in-law. So the imprint is that of the money men, not the original creative genius. Some things never change.

During the next century, paper, printing presses, and books—essential ingredients for the Renaissance—prolifer-

ated throughout Europe. The rapid spread of the presses was due in part to the fact that they worked a lot like existing grape and olive presses, which were already common and could be converted fairly easily. It's estimated that nearly seventeen hundred printing presses had started up by the end of the fifteenth century.

William Caxton was the first important English printer. His 1475 translation of a French history of Troy was the earliest printed book in English. In the next twenty years he published over one hundred books, his list encompassing nearly all of England's literature that existed at the time—most of Chaucer, Sir Thomas Malory's *Le Morte d'Arthur*, and much by John Lydgate, whose memory lingers on today only in Ph.D. seminars.

So the technology needed to produce paper money was widespread in Europe by Shakespeare's time, but nobody got around to trying it in a serious way until the mid-seventeenth century. This was due in part to the fact that it wasn't really needed.

Columbus's stumbling into the New World in his search for a new route to Asia—he was dead certain he'd reached China when he first saw Cuba—and the rapacious plundering of the Aztec and Inca empires that rapidly followed, along with ambitious mining operations worked by local slave labor, sent a gleaming tidal wave of silver and gold rolling toward Europe. Between 1500 and 1540, nearly thirty-five hundred pounds of gold reached Spain alone every year. Then in 1545 the vast silver deposit at Potosí, in what is now Bolivia, was discovered, and more slaves, recently proud Incas, were per-

suaded to commence digging. Most of this plunder was made into coins, which were then mainly used to finance wars and other grand enterprises.

This meant that during the sixteenth century Europe had an abundance of hard cash.

Spanish pesos and Portuguese pieces-of-eight ruled, and would continue to do so in North America until well after the American Revolution.

The silver dollar also made its first appearance at this time, in 1520 in a small town in Bohemia. One Count Stephan Schlick discovered silver deposits in the valley of Joachimsthal near his home in Jachymov, and began minting large silver coins that came to have the throat-clogging name of *Joachimsthalergroschen*, soon understandably shortened to *thalers*. Nearly 250,000 were coined the first year, and before the century's close over ten million thalers from the Jachymov area were in circulation all over Europe and the rest of the world.

The name for these popular coins stuck, mutating as it went. As Jack Weatherford sums it up in *The History of Money*, "The words passed into Italian as *tallero*, into Dutch as *daalder*, into Danish and Swedish as *daler*, into Hawaiian as *dala*, into Samoan as *tala*, into Ethiopian as *talari*, and into English as *dollar*. It also became part of the name of the Swedish *riksdaler* and the Danish *rigsdaler*." He adds that "during the sixteenth century, approximately 1,500 different types of thalers were issued in the German-speaking countries."

There was a downside to the huge

volume of hard currency produced in Europe during the sixteenth century. For people like me, economics is not only the "dismal science," it's the utterly baffling one. Virtually *any* condition, it seems, can cause inflation, and one such is having too much money in circulation, even if it's good solid cash. I guess having more money in hand to throw around tends to make buyers more fancy-free, and sellers more crafty. One imagines an economic transaction of the era:

> *Like that horse?*
> *I sure do. How much?*
> *Oh, 300 thalers.*
> *But it was only 200 yesterday!*
> *You want it or not?*
> *Well, I've got the cash....*

In any case, all these coins flowing around were a major cause of extreme inflation in Europe between 1540 and 1640. At the same time, population growth didn't result in a corresponding increase in production, due in part to a shift of population toward the cities, making people more dependent on markets instead of producing what they needed themselves. The inflationary leap was so considerable that the period is known in money histories as "The Price Revolution."

Other historic, societal—and financial —changes during this time led, finally, to paper money. All the voyages and colonizing in the years after Columbus both shrank and opened up the world, creating an international commerce unprecedented in history. This qualitative leap in the worldwide extent and complexity of getting and spending led to the rise of most modern financial practices and institutions.

The first English joint stock company was created in 1553, an enterprise called the Russia Company whose investors hoped to make their fortunes by finding a North-*east* passage to Asia. Wrong! In 1585, the Bank of Genoa was founded, followed two years later by the Banco di Rialto in Venice. The London East India Company came along in 1600, and its more famous competitor, the Dutch East India Company, began in 1602. Both brought in hundreds of shiploads of imports from the East, but sent hard cash the other way, which contributed to the inflationary spiral. In 1609 the first important banks in Amsterdam and Barcelona opened their doors. Between 1615 and 1621, German banks in Middleburg, Hamburg, and Nuremburg were founded. Even wild and crazy Italian double-entry bookkeeping, which had been around for over a century, was finally adopted in monetarily staid England. In Europe at this time, finance was all the rage.

Somewhat by accident, goldsmiths became the first bankers in England, and issuers of the first "banknotes" that led to English—and colonial—paper money. The goldsmiths had secure safes, and began taking in deposits of valuables, issuing receipts.

This practice became increasingly popular with wealthy Royalists in the early 1640s when Cromwell and his "round-head" Puritan armies began battling King Charles I's forces, eventually sending him fleeing. Charles was twice captured and escaped, but was finally delivered up and executed in 1649. The so-called Interregnum lasted until 1661, when his son Charles II, nicknamed "The Merry Monarch," took the

throne and Restoration partying began.

The earliest surviving English goldsmith's receipt is from 1633. From there, as H. Withers put it in his 1909 *The Meaning of Money*, "Some ingenious goldsmith conceived the epoch-making notion of giving notes not only to those who had deposited metal, but also to those who came to borrow it, and so founded modern banking." These began circulating in a small way as payments of debts, and this led by natural extension to the more all-purpose goldsmith's banknote, redeemable by any bearer who brought it in. The first reference in English to such banknotes is in the diary of that tireless scribbler Samuel Pepys, who recorded sending one to his father in 1668 to pay off six hundred pounds that he owed him. These were all private issues by individual firms, and not yet paper money as we think of it today—and certainly not in the way they looked.

The first nationally chartered bank to issue such notes was Sweden's, in 1661.

But the real beginning of government-backed paper money as we now know it came in the Massachusetts Bay Colony—which in 1690 produced the first in the history of western civilization, to pay soldiers returning from an unsuccessful assault on Quebec. Fitting, really, since paper money had its inception hundreds of years earlier in China in connection with military problems—and has continued to be associated with wars and skirmishes ever since. Both the American and French Revolutions were primarily financed by printing presses churning out paper money, as was the American Civil War.

In fact, we owe our current U.S. "greenbacks" to that one. The hideous hyperinflation that accompanied the issue of "Continentals" during the Revolution was such a cautionary that soon after the war ended the new U.S. government itself went out of the paper money business—though literally hundreds of state and private banks kept at it—and didn't jump back in until the Civil War, shortly after hostilities began. It's been the exclusive producer of our money ever since—if you don't count enterprising counterfeiters, that is.

The art on paper money has evolved tremendously during its 300-year history in the west. Every techonological advance in printing and paper that came along has gradually been incorporated, so that paper money (though some of it, such as Australia's, is *plastic* today!) has evolved its own special aesthetic. The canvas is small compared to most graphic art forms, but the uses to which it's been put couldn't be too much more varied and imaginative.

Section I: INTERNATIONAL

PEOPLE

NATIONAL HEROES

It should come as no surprise that the most common images on money are pictures of people. But which ones? Who's important or interesting enough to deserve a place? The answers are as different as the countries themselves.

Since money is such a handy tool for propaganda, national leaders, current and historic, are at the top of the list—political figures and royalty being the two main categories—tangible reminders of who's in charge. One result of this is that the faces of a lot of the world's bills are occupied by stiff, boring portraits of people that no one outside the country in question has ever heard of.

This is true, too, in regard to many bills featuring national heroes who have done something more significant than run the country through election, heredity, or forceable armed takeover. A proportion of the "important" people on world currencies are internationally known—but by far, most would hardly be given the time of day beyond their own borders. They don't mean squat two doors away.

Given the standard cultural bias in what has passed for my education, I didn't feel *too* bad about not knowing who D. Sukhbataar was on the Mongolian fifty tugruk, say, or Alhajji Sir Abubaker Tafawa Balewa (who gets the prize for the longest name I encountered) on Nigeria's five naira. I was relieved to find that my *Encyclopaedia Britannica* knew them both. Sukhbataar was a revolutionary leader in the Mongolian war of independence from China after World War I, and Balewa was Nigeria's first federal prime minister, killed in an army coup in 1966.

But I felt like I ought to know the face on Canada's $5 bill, its lowest paper denomination since the $1 and the $2 have devolved into coins, thanks to inflation. He's certainly distinguished-looking, with his stiff collar and elegantly receding hairline. But I didn't have a clue. Nor did I recognize the fellow on Canada's $10. For a nano-second I thought it might be Pat Paulsen from the old "Laugh In" TV show, but figured it probably wasn't. It was a bit mortifying to realize that I knew so little about our great neighbor to the north.

I learned that the fellow on Canada's $5 note (figure 1) is Sir Wilfrid Laurier, whose dual claims to fame were serving the longest unbroken term as prime minister (1896–1911) and being the first French-Canadian so elected. I guess he's on the bill as a bow to the French-speakers who want their own country. His renowned slogan was "The twentieth century belongs to Canada." Nobody's perfect. The high-collared gent on the $10 (figure 2) is Sir John Macdonald. He was Canada's first prime minister, serving twice, 1867–73 and 1878–91. He resigned his first term in response to charges of corruption in what became known as the Pacific Scandal. By some coincidence, the lucrative contract to build a railroad to the Pacific was awarded to a big contributor to Macdonald's 1872 campaign. His opponents howled "Bribe!," Macdonald quit, and the contract was

cancelled. "Though accused of devious and unscrupulous methods," says my trusty *Encyclopaedia Britannica*, "he is remembered for his achievements."

After looking at bills from almost all of the 230-odd countries that produce their own paper money, I found that the Obscurity Factor, on a scale of 1 to 10, with 10 representing Instant Recognition, varies from country to country, but, for me at least, generally hovers right around 1. Or maybe 0+. I guess I slept through more classes than I realized. And don't read *The New York Times* as often as a decent citizen should.

France is fairly easy, but then the names are printed with the portraits, which helps. I'd at least heard of them all. Claude Debussy on the 20 franc, Saint-Exupéry on the 50, Paul Cézanne on the 100. Gustave Eiffel on the 200, and the Curies, Madame and Pierre, looking a little radioactive themselves on the neon-lime-colored 500, fill out the roster of current French bills.

Switzerland, though, right next door, has a fairly arcane bunch on its money. The people on the bills are material for "Final Jeopardy" questions. Leonhard Euler, Le Corbusier, Horace-Benedict de Saussure, Konrad Gessner, Sophie Taeuber-Arp, Francesco Castelli, Charles Ferdinand Ramuz, Albrecht von Haller, Auguste Forel, and Jacob Burckhardt. I was two-for-ten. I knew who Le Corbusier was, though I couldn't exactly say what he designed, and remember reading Burckhardt's gossipy anecdotes about naughty Renaissance Popes in an undergraduate history course—but I'd always thought he was German.

It's true for most of the world's currencies—with some notable exceptions, local heroes remain pretty local.

FIGURE 1

Sir Wilfred Laurier, Canada's first French-speaking prime minister, 1896–1911.

FIGURE 2

Sir John Macdonald, Canada's first prime minister, 1867–1873. Forced to resign on charges of corruption, he made a comeback and served again, 1878–1891. Any resemblance to Pat Paulsen is coincidental.

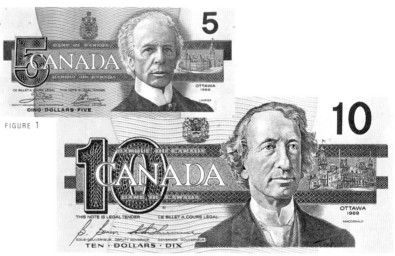

FIGURE 1

FIGURE 2

QUEEN LIZ

The most ubiquitous famous face on today's paper money is that of Queen Elizabeth II. She's on at least thirty-seven different currencies, though some of them share the same plates. And even here, countries reveal their differences—as well as how up-to-date they are. She was the first monarch ever to appear on British money. Oddly, the Bank of England bills (figure 3) are the least flattering. She's squinting slightly, her mouth a bit puckered like she's just eaten something that didn't quite agree with her, and she resembles Prince Charles in drag rather more than one might want.

Queen Elizabeth has grown old on money around the world, passed from hand to hand. On a 1953 bill from the Bahamas (figure 4), issued a year after she was coronated, she's young and fetching. She's still that way on the money of certain laggardly countries that haven't gotten around to updating their portrait plates. She was looking remarkably young for her age in Belize as recently as 1976 (figure 5), and on a 1987 (figure 6) issue was still hardly showing the years. But by 1990,

Father Time had caught up with her—and the Belize mint—and she's also sharing the stage with a lobster, another indignity of sorts (figure 7). Today she's still pretty age-defying on Isle of Man and St. Helena money, and most grandmotherly on the most recent Bahamas, Fiji Islands, Gibraltar, and Guernsey issues, all of which use the same engraving. In some of these places she's two ages at once, since earlier and current bills are both in circulation.

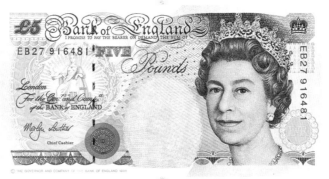

FIGURE 3

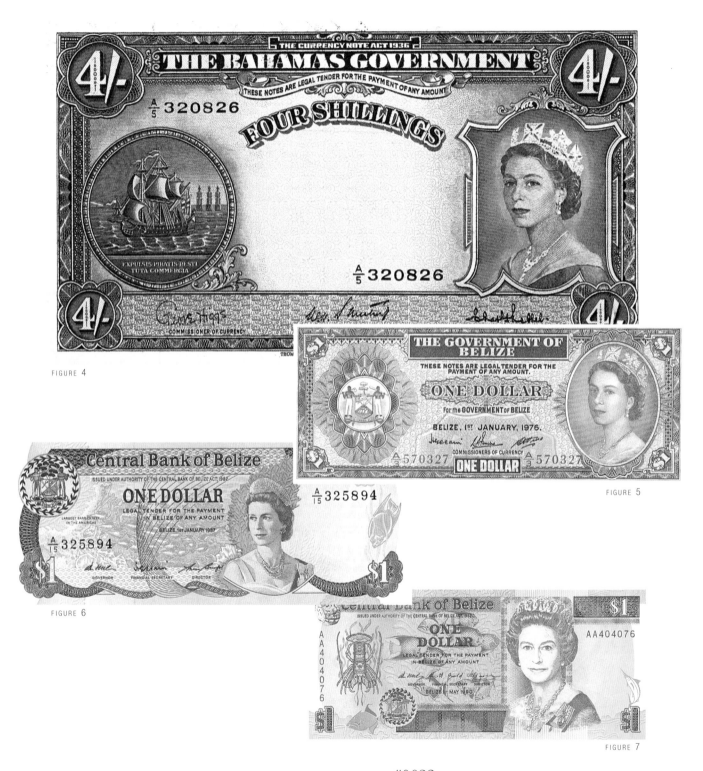

FIGURE 4

FIGURE 5

FIGURE 6

FIGURE 7

Another odd aspect of all these Queen Elizabeths is the different getups she's wearing in different places. The fashion statements are telling as well. On some, she's all dolled up in an ostentatious crown and dripping diamond earrings and necklaces. On a few others from the 1960s (figure 8), she's wearing a romantic-looking military outfit and suggests Ingrid Bergman playing Joan of Arc. And in egalitarian Canada and Australia, where they love their queen but love their democracy as well, she wears no crown, a sensible dark dress, and just a simple string of pearls. She's the people's queen, too (figure 9)!

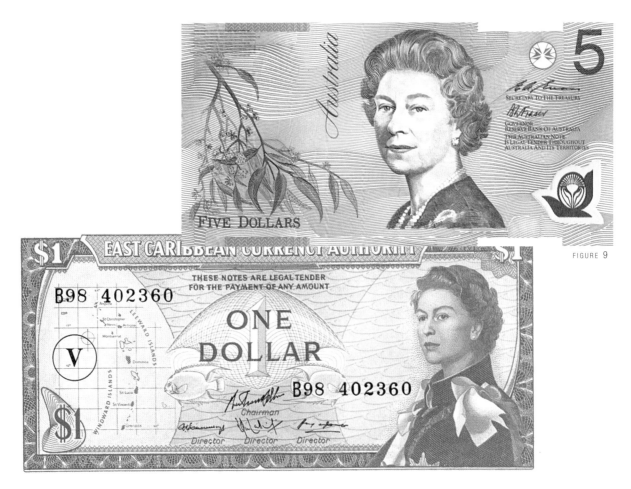

FIGURE 9

FIGURE 8

page #0033 QUEEN LIZ

THE GREAT & THE NEAR-GREAT

Happily, most countries recognize that there are areas of significant human endeavor beyond politics and government—something you'd never learn by looking at current U.S. money, which is resolutely devoted to pictures of politicians and the austere buildings associated with them. As will be seen in the section on the history of U.S. money, this wasn't always the case. But for the last seventy years it's been monomaniacally so, our currency having plummeted straight downhill in terms of variety and richness of imagery since the turn of the century. Not so elsewhere, thank goodness. People get commemorated on bills who have actually done something beyond running the country. Artists, writers, scientists, explorers, inventors, musicians, architects—in short, a great range of people whose achievements have been considered positive contributions to what passes for the human condition, a claim few politicians can make with a straight face. Some of these local heroes are little known and unremembered outside their own countries, while others, though internationally famous, have faces that don't register on the Celebrity Scale. Here's a nonpolitical gallery of greats:

Men's Division

FIGURES 10A & 10B

Of all twentieth-century world authors, James Joyce is arguably the most celebrated, if the least actually read cover to cover. This bill from Ireland cleverly features a portrait of him on the front, with an ancient bust of the original Ulysses on the back.

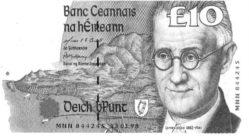

FIGURE 10A

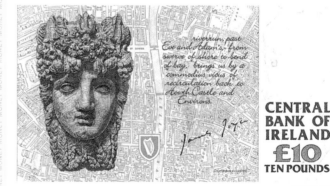

CENTRAL BANK OF IRELAND £10 TEN POUNDS

FIGURE 10B

Look! Up in the sky! It's ...
J. Abelardo Quiñones! This bill tells
a terrific story, if finally a tragic one.
In 1941, while World War II was
occupying nearly everyone's atten-
tion, a short, bloody border war
broke out between Peru and Ecuador.
Both sides claimed the other invaded
first. Peru won, coming away with a
huge chunk of Ecuador's piece of the
Amazon basin. Even such unnoticed
conflicts have their heroes. Quiñones
(figure 11A) was a twenty-one-year-
old Peruvian aviator, and one of the
original fearless hotdogs—flying an
upside-down evasive maneuver (fig-
ure 11B) in one battle before he was
finally killed in action.

FIGURES 12A & 12B

Belgium proves itself truly hip by so
beautifully commemorating Adolphe
Sax (figure 12A), who patented
his saxophone in 1846. We wouldn't
have had Charlie Parker or early
rock & roll without him. But, sadly,
he peaked with the sax. His other
musical inventions included the sax-
horn, the saxo-tromba (with a sound
somewhere between a bugle and a
trumpet), and the saxtuba. None had
the lasting power of his saxophone.
At the age of eighty he found him-
self dead broke. Fellow musicians
Massenet and Saint-Saëns had to
petition the government to help him
out. The back of the bill is the only
one that brings the word "soulful" to
mind (figure 12B).

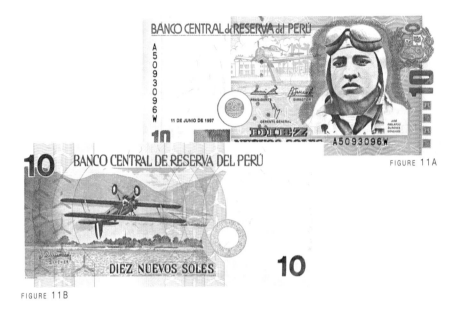

FIGURE 11A

FIGURE 11B

FIGURE 12B

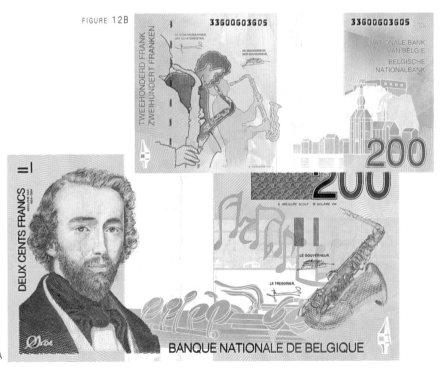

FIGURE 12A

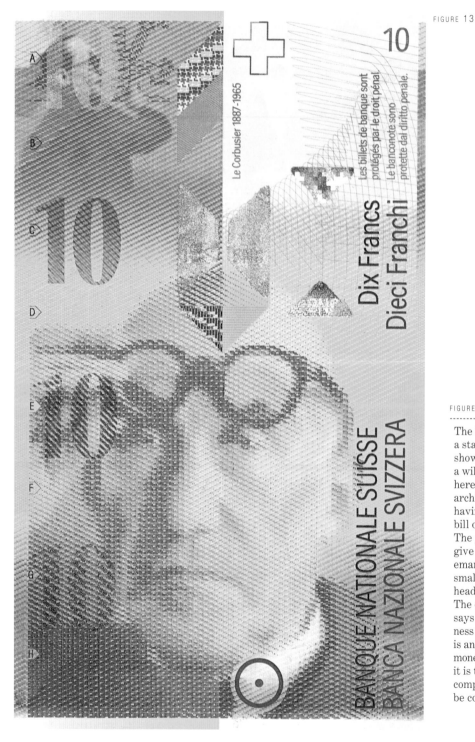

FIGURE 13

Le Corbusier 1887-1965

Les billets de banque sont
protégés par le droit pénal.
Le banconote sono
protette dal diritto penale.

10

Dix Francs
Dieci Franchi

BANQUE NATIONALE SUISSE
BANCA NAZIONALE SVIZZERA

FIGURE 13

The Swiss have a reputation as
a staid, proper bunch, but it hardly
shows on their money—which has
a wild, surreal quality. Pictured
here is Le Corbusier, the visionary
architect, and it sure looks like he's
having one. You have to stand the
bill on end to "read" the image.
The yellows rising from his head
give the impression of nuclear fusion
emanating from his brain, with a
small spaceship landing on his fore-
head—or being launched from it.
The over-the-top complexity actually
says something about Swiss fussi-
ness regarding money. Counterfeiting
is an enormous problem with paper
money, and one effective dodge against
it is to design bills mind-bogglingly
complicated enough to make would-
be counterfeiters weep.

Gustave Eiffel's tower seemed to many visitors to the 1889 Centennial Exposition an ugly, modern blight on the classic Parisian cityscape— and now it looks, well, quaint and old-fashioned. But this rendering of Eiffel and his sculpted metal tinkertoy creation (figure 14A) on a current French bill certainly doesn't. The tower is a post-expressionistic purple swirl, and the point of view on the back (figure 14B) is fresh and unexpected, a peep through its feet at the Saint-Louis church dome that rises glowing above the Hotel des Invalides complex where Napoleon has come to rest. Scheduled to be demolished in 1909, the tower was saved not for aesthetic reasons, but because it made such a great antenna for radio transmissions. It remained the world's tallest building until New York's Chrysler Building came along in 1930.

FIGURES 15A & 15B

A whimsical small fellow from Asteroid B-612, The Little Prince is pictured on this French bill with his creator, Antoine de Saint-Exupéry, (figure 15A) with their favorite way to get around and have adventures— in rickety-looking airplanes (figure 15B). Born in 1900, Saint-Exupéry was one of the first writers to celebrate the romance of the air, based on his own considerable experience as a pilot. In the 1920s and 1930s he helped establish airmail routes in North Africa and over the Andes in South America, and despite serious disabilities resulting from flying accidents, was a reconnaissance pilot during World War II. He died in 1944 during a flight over the Mediterranean.

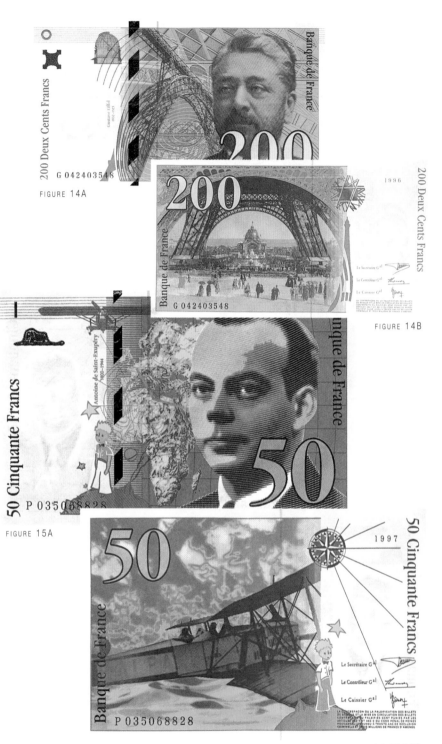

FIGURE 14A

FIGURE 14B

FIGURE 15A

FIGURE 15B

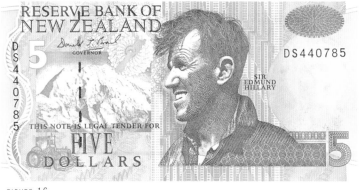

FIGURE 16

FIGURE 16

Sir Edmund Hillary, on New Zealand's $5, ranks as Most Rugged Outdoorsman on world money, with his weather-crinkled eyes, windblown hair, and open-throated shirt casually askew—even the color suggests the lifelong tan only acquired by someone who at thirty-three was the first to stand on top of Mount Everest in 1953, who led the first successful expedition to cross Antarctica via the South Pole in 1958, and who climbed to the source of the Ganges River in the Himalayas in 1977. Pretty heady stuff for a New Zealander whose first occupation was as a beekeeper.

FIGURE 17

This 1996 commemorative note celebrates Bhumibol Adulyadej's fiftieth year as Thailand's king. Shown sitting on one of his portable thrones, his outfit suggests the Wild West transported to Southeast Asia. With only ceremonial powers, he travels the country talking to regular people and is a popular populist. Born in Cambridge, Massachusetts, in 1927 while his father was studying at Harvard, he was educated in Switzerland and assumed the throne at the age of eighteen in 1946 after his older brother was shot and killed. He's pretty cool—he paints, builds his own sailboats, and plays saxophone in his own jazz combo.

FIGURE 17

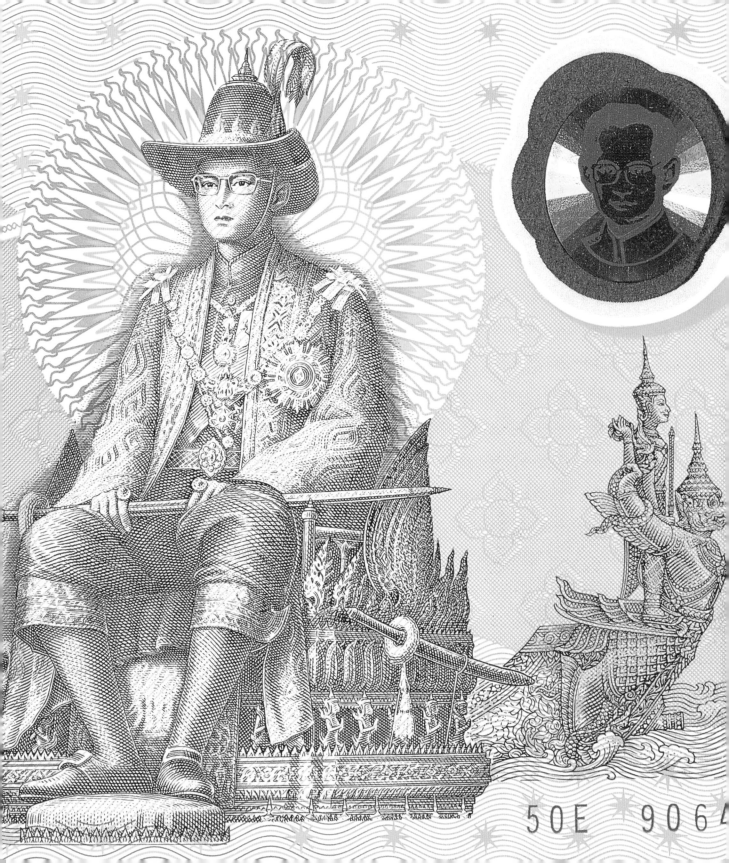

50E 9064

Women's Division

Women are drastically under-represented on world currencies. There are a few monarchs, such as Queen Elizabeth, and lots of generic images of "typical" women from many countries, plus a number of lovely allegorical or mythological damsels, but there are far more birds, tractors, or buildings on money than specific important women. U.S. paper money is among the worst in this regard. Not counting a historical "vignette" of Pocahontas being baptized on a Civil War–era note, the only woman who's *ever* appeared on a U.S. bill was Martha Washington, twice — and on one she's shown, of course, next to George. That's it. So in American daily transactions we get to look at grim Alexander Hamilton and Andrew Jackson instead of Billie Holiday, Amelia Earhart, or Marilyn Monroe. But some countries aren't as sexist and boring.

Germany, not necessarily known for its enlightened attitudes in these matters, gets equal-time points by featuring distinguished women on *half* of its current bills — though few outside the country may have heard of Bettina von Arnim, Annette von Droste-Hulshoff, or Maria Sibylla Merian (respectively — major nineteenth-century Romantic writer; nineteenth-century poet and storyteller whose tales were forerunners of modern realism; eighteenth-century painter of plants, insects, and reptiles, a German precursor of Audubon).

Of Denmark's eight current bills, five show women, and one, the thousand kroner, depicts a couple, painters Anna and Michael Ancher.

It should be observed, too, that the achievements of the women who *have* made it onto money are, in the aggregate, considerably more positive and salutory than those of their often scoundrelly male counterparts — but then women are generally more decent than men, anyway. Here are a few standouts:

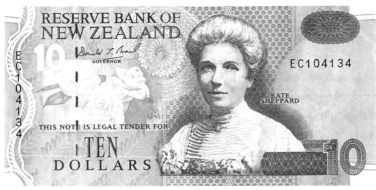

FIGURE 18

FIGURES 20A & 20B

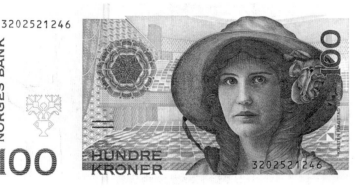

FIGURE 19

FIGURE 18

To appreciate what a strong feminist—and nationalist—statement this current New Zealand $10 bill is, it's useful to note that until 1992, Queen Elizabeth occupied this space. Now it's Kate Sheppard—one of the most tireless, and successful, leaders in the history of the women's suffrage movement. Born in England in 1847, she was taken by her widowed mother to New Zealand when she was twenty-one. She married two years later, but the union didn't exactly thrill her, and probably influenced her then-unorthodox views regarding traditional gender roles. She advocated economic independence for women, equal pay, the desirability of women's personal fulfillment through a career, and, of course, the vote. She led a long campaign that resulted in New Zealand's becoming, in 1893, the first country in the world where women could vote.

FIGURE 19

Now there's a hat! Not some strong beauty out of a Virginia Woolf novel, this is Kirsten Flagstad, a Norwegian opera singer who, during a long career beginning in the early 1930s, became the greatest Wagnerian soprano of the mid-twentieth century.

FIGURE 20A & 20B

The wearer of this even more major hat is Selma Lagerlof (figure 20A), a Swedish novelist who in 1909 became the first woman to win the Nobel Prize for Literature. Her most beloved work was *The Wonderful Adventures of Nils*, a two-volume children's book commissioned by the government as a school geography—Nils is shown (figure 20B) flying over Sweden on the backs of some accommodating geese—which proved that work on demand could sometimes become art. Her other books included romantic evocations of peasant life and a socialist novel about Sicily. Deeply committed to the cause of beleaguered Finland during World War II, she donated her gold Nobel Prize medal to a collection being taken for the struggling country.

FIGURE 21

It's fitting that this portrait of Norwegian author Sigrid Undset appears against a stylized medieval tapestry, and that the holographic ribbon running down the right is drawn from wood-carving motifs from Norway's eleventh-century Urnes church. Her masterpiece, the trilogy *Kristin Lavransdatter*, published 1920–22, is a medieval epic. Undset won the Nobel Prize in 1928, and became so *personally* medieval that in later years she lived in a house restored to its authentic A.D. 1000 prime, and dressed in the ancient style of a Norse matron.

FIGURE 22

No, it's not Benjamin Franklin's sister. This is Mary Reibey, an early settler in Australia—if involuntarily so—and a true rags-to-riches story. Born in England in 1777, both her parents died when she was young.

She was made an indentured servant, ran away at fourteen, stole a horse, got caught, and was "transported" to New South Wales. At seventeen, she married Thomas Reibey, who went on to found an extremely successful shipping business extending to India and China. When he died in 1811, she took over, raising their seven children alone, further expanding the business and buying considerable property in Sydney. At her death in 1855, the ex-convict waif was one of the wealthiest people in Australia.

FIGURE 23

Golda Meir led a life committed to the founding, and then the preservation, of the state of Israel. Born in Kiev in 1898, she moved with her family to Milwaukee, Wisconsin, when she was eight. As a teenager she became a leader in Milwaukee's Labor Zionist Party. She married and moved to Palestine in 1921, continuing her efforts through

World War II, becoming a signer of Israel's declaration of independence in 1948 and its first ambassador to Moscow. She was appointed foreign minister in 1956, and elected prime minister in 1969, serving until her retirement in 1974.

FIGURE 24A & 24B

Her face quietly beams a deep tranquil sympathy and warm understanding (figure 24A), and her students, on the back (figure 24B), seem peacefully absorbed in their tasks. She is, of course, Maria Montessori, the turn-of-the-century Italian educator whose theories of early education emphasized the creative potential of children and the importance of treating them as true individuals. There must be something to it. Today hundreds of Montessori schools are in operation all over the world.

FIGURE 21

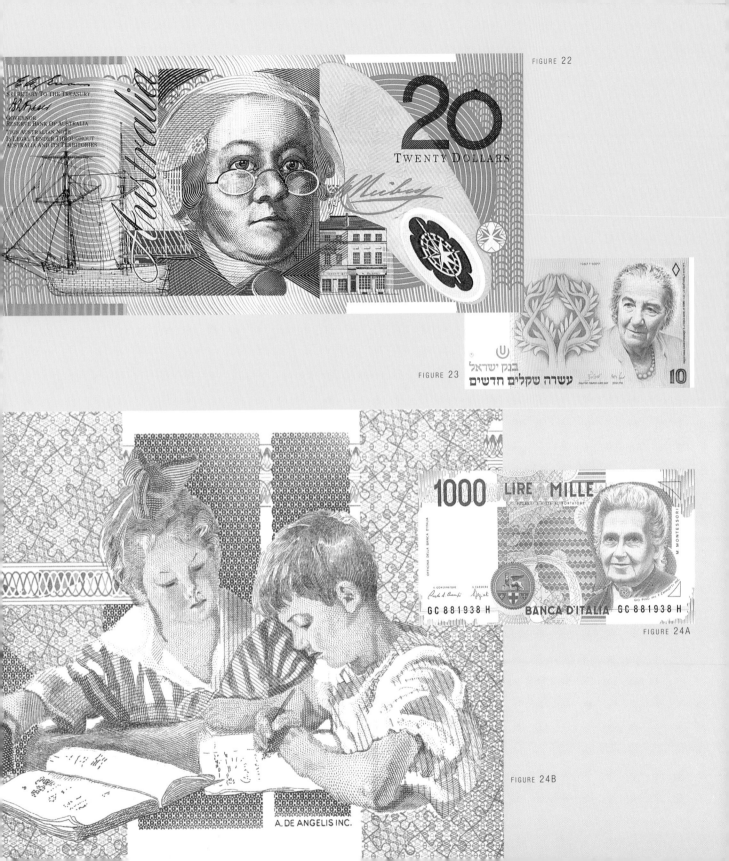

FIGURE 22

FIGURE 23

FIGURE 24A

FIGURE 24B

TOUGH GUYS

A few currencies feature portraits of guys you wouldn't really want to meet in a dark alley. On Central and South American money, it would be tempting to attribute this to Latin *machismo*, and the fact that they're on the money probably speaks to that—but the most intimidating-looking are from cultures that antedate the Spanish takeover of their countries. Faces on Mexican, Guatemalan, and Ecuadoran bills exhibit a mythic power and grandeur. They represent indomitable resistance to oppresssive authority.

The solemn and somehow thoughtful-looking figure on Mexico's hundred peso note is Netzahualcóyotl (figure 27), an Aztec ruler of a state on the eastern shore of Lake Texcoco, now defunct, having been filled in and become part of Mexico City's vast smoggy sprawl. His name translates as "Fasting Coyote." He was the son of Ixtlilxochitl. When he was ten he fled with his father from rivals who wanted to kill them both and end their royal line. At a final showdown, his father ordered him to climb a tall tree. His father was killed, but Netzahualcóyotl went unnoticed. He grew up in exile with a price on his head, but lived to rule his home state from 1431 to 1472. He became a symbol of opposition to tyranny, and, while a formidable warrior, was also a poet, writing, as Mexican historian T.R. Fehrenbach puts it, "about the vanity of men and the mutability of fortune."

Guatemala's Tecun Uman, shown on its half quetzal note with the quetzal bird

sacred to the Maya (figure 26), didn't fare as well, but his story is literally magical. He died in 1524, in a great battle against a Spanish army led by one Don Alvarado. But what a way to go. Here's how John L. Stevens described it in his classic 1841 *Incidents of Travel in Central America*:

"The Spaniards began fighting the ten thousand Indians which this Captain Tecum brought with him ... They fought for three hours and the Spaniards killed many Indians. Then Captain Tecum launched himself into the air, *for he had transformed into an eagle, covered in* [quetzal] *plumes* ... He had wings that also sprouted from his body and he wore three crowns, one of gold, one of pearls, and one of diamonds and emeralds." He flew at Alvarado, took a swipe with a magical lance, but missed, cutting off Alvarado's horse's head. When he saw this, "he turned and flew up, so as to swoop down and kill Alvarado. But then Alvarado guarded himself with his lance and he speared Captain

Tecum through the middle....afterwards he told his soldiers that he had never seen an Indian so gallant, so lordly, and so bedecked in such beautiful plumes."

My favorite is on Ecuador's thousand sucre note (figure 25). The portrait is of Ruminhaui, his strong determined face scowling up into the sky in defiance of whatever you've got. He looks like Charles Bronson of the Amazon—and gets my vote as the toughest-looking guy on any money in the world. He was a lieutenant of Atahualpa, the last Inca king. After his boss's capitulation in the Spanish invasions, Ruminhaui rebelled, took over Quito, and butchered the remnants of the royal household to show his disdain for Atahualpa's surrender. He had Atahualpa's brother, Illescas, skinned and made into a drum. The Spanish eventually did him in, but he went down fighting.

Don't mess with Ruminhaui!

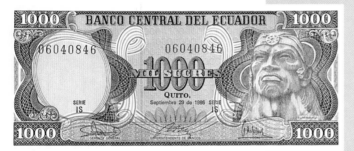

FIGURE 25

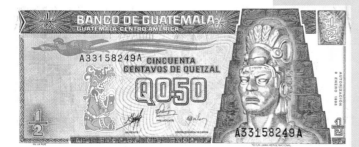

FIGURE 26

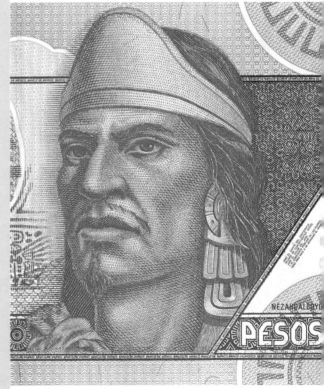

FIGURE 27

TOPLESS MONEY

Some money is even *sexy*. It's a wild notion for Americans accustomed to conducting business with dour old faces and austere impersonal buildings, but some countries reveal a considerably more earthy attitude, an appreciation and celebration of the human form, an admission that we are flesh, after all, and that some of it is really nice to look at.

Many are allegories—embodiments of certain virtues, ideals, or human qualities, which pretty often just *happened* to be embodied before they got dressed in the morning. Liberty, especially, is like that. She seems never to have all of her clothes on. But then she's a free spirit. Mythological figures, intellectual cousins to allegories, generally get a similar treatment, with minimalist wardrobes and/or wearing garments that really wouldn't be suitable in cold weather.

The other common impulse behind topless money is one that's served *National Geographic* well for over a hundred years—cultural verisimilitude. Sure, they're naked, or nearly so, but that's how the natives dress—or rather don't—in these places. We're just being anthropological here! Never mind that these edenic maidens (plus a few token guys) happen to be fetching, too.

The most extravagant cases of nudity (and the most of them) are from France, and the countries that were its former colonies, which still share—on their money, at least—a sense and appreciation of aesthetics, French-style.

FIGURE 28

Liberty appears on this French bill as a zaftig revolutionary holding a flag aloft and a bayonetted rifle, her gown partially ripped away, presumably from her efforts to free France from the tyranny and chocolate cakes of the Ancien Régime—a detail from the famous painting by Eugéne Delacroix, whose portrait is featured here.

FIGURE 29

Mercury, on this French bill from the 1940s, looks a little worn out. But he was a busy guy. Along with being messenger for the gods, according to *Bulfinch*, "he presided over commerce, wrestling, and other gymnastic exercises, even over thieving, and everything, in short, which required skill and dexterity." No wonder he's taking a breather.

FIGURE 30

This prosaic rural gent's no Mercury, but he does have his shirt off, though he's kept his hat on, taking a break from cutting all that hay by hand with a little sickle. From Luxembourg in 1943, this bill is a reminder of how long farming continued as it had for centuries, even in civilized Europe.

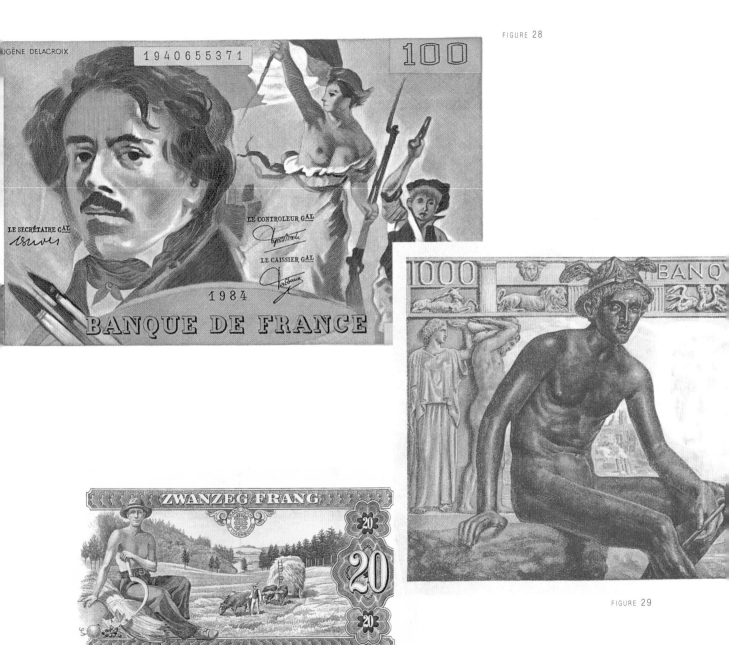

FIGURE 28

FIGURE 29

FIGURE 30

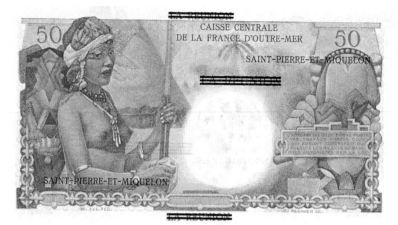

FIGURE 31

FIGURE 31

The young "native" here is so attractive it's hard to believe she's recycled. But this 1960 bill from Saint-Pierre-et-Miquelon is an over-print, originally made for the French *département* of Reunion, a tropical island in the Indian Ocean. This would explain the anomaly of a topless native belle appearing on money from two small, chilly islands just off Newfoundland (also French *départements*).

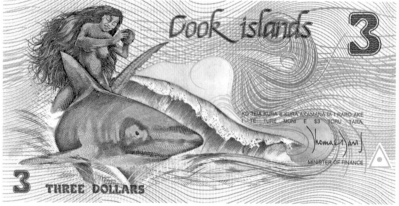

FIGURE 32

FIGURE 32

Hard to say why this woman is riding that shark, but she should be happy. The fifteen Cook Islands, spread over an area the size of India, lie two thousand miles northeast of New Zealand in the middle of par-adisaical nowhere, with no highrise hotels or mojo resorts, and mercifully few tourists to junk things up.

FIGURE 33

These pretty maidens all in a row are the featured celebrants in one of tiny Swaziland's major cultural events, the Umblanga, or Reed Dance. Every year they gather for five days to perform at the Queen Mother's home in Lobamba, dancing, singing, and cutting reeds to make ceremonial (and real) repairs to the windbreaks surrounding the Queen's village. The ranks of young women are a traditional way to symbolize the country's unity.

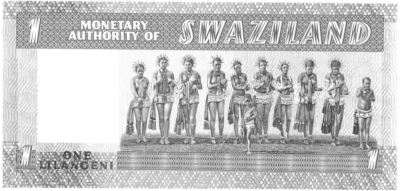

FIGURE 33

JUST FOLKS

Some countries choose to depict representative, everyday people who sum up what is special and particular about their culture. Those that were once part of France's colonial empire, or continue to be French *départements*, produce the most beautiful bills of this kind, especially countries in Africa, Indochina, and the French Pacific. A number of non-French currencies have their regular people standouts as well. One has to appreciate the egalitarian impulse behind them all—although there's a sexism even in these "real people" bills. In terms of identifiable individuals, far more men than women turn up on money; but on bills showing just plain folks, the balance tips noticeably the other way—more "generic" women than men. Though I suppose Everywoman is better than No Woman.

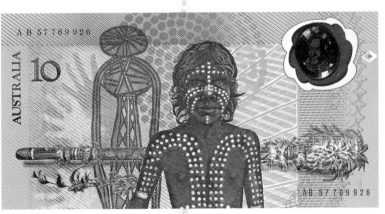

FIGURE 34

Striking and quietly powerful, this reverse side of a 1988 Australian Bicentennial bill represented a small redress of wrongs, celebrating the aboriginal people who had occupied the island continent for seventy-five thousand years before the first Europeans came along in 1788 and began systematically wiping them out and/or driving them from their traditional lands—just as they'd begun doing in North America over one hundred years earlier. Designed by aboriginal artists, the note shows, along with the youth painted in ceremonial body markings, an example of traditional rock paintings, and a North Arnhem Land Morning Star Pole, an aboriginal totem of great significance. Ironically, the figure in the hologram, floating like a (bad) dream balloon, is Captain James Cook, the intrepid explorer who started all the trouble for the aborigines.

Hard to get much lovelier than the one-two of the face (figure 35A) and back (figure 35B) on this 1985 note from French Polynesia. But then the islands encompassed by the territory pretty much define Paradise: Tahiti, Moorea, Bora Bora, Hiva Oa, Nuku Hiva—made part of our imaginative landscape by artists and writers such as Paul Gauguin, Robert Louis Stevenson, Somerset Maugham, Herman Melville, and even Jimmy Buffett.

FIGURES 36 & 37

Both bills here, from the 1950s, offer a charming example of the same visual motif as shown by different cultures: a local woman holding a basket of flowers. One is from Bulgaria (figure 36), and the scene seems quintessentially central European. She's a hard-working Balkan peasant. The other lady, from Laos (figure 37), shows the distinct influence of French colonialism—as does the note itself.

FIGURES 38 & 39

The handsome fellow in figure 38 is from Mali, a member of the West African States, comprised of Benin, Burkina Faso, Ivory Coast, Mali, Niger, Senegal, Guinea-Bissau, and Togo. With its flowing lines and elegant coloring, this handsome bill from the Central African Republic (figure 39) exhibits a subtle, pleasing, loveliness of overall design.

FIGURE 40

On one of the most graceful bills of all, this young woman in a patterned, sun-colored shawl, from Madagascar and the Comoros Islands, has a serene madonna-like quality enhanced by the peaceful beauty of the orchids seeming to embrace her.

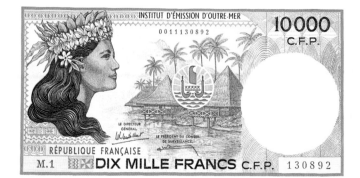

FIGURE 35A

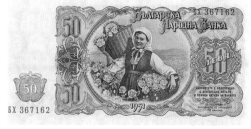

FIGURE 36

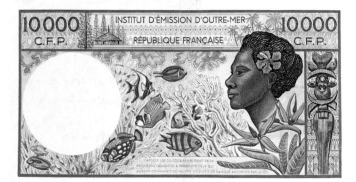

FIGURE 35B

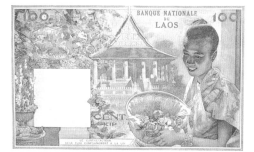

FIGURE 37

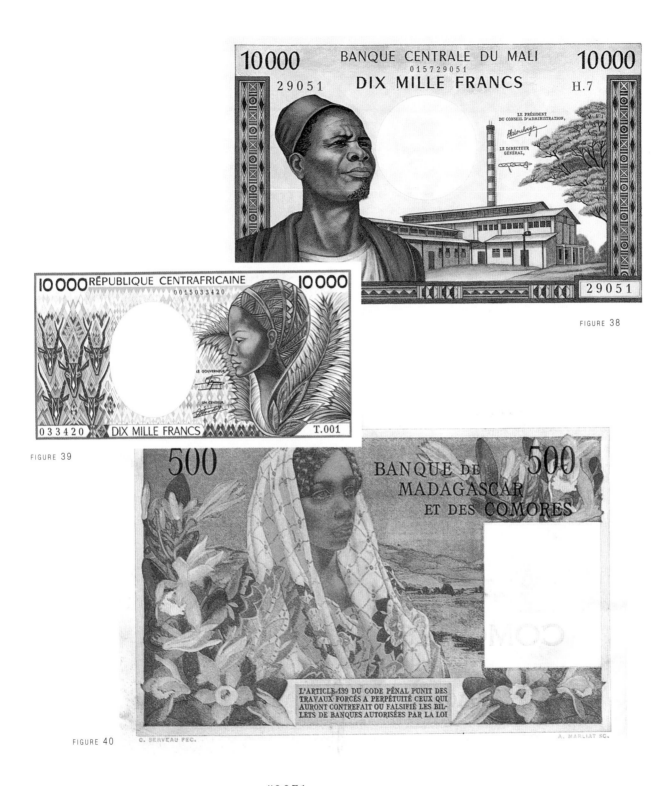

FIGURE 38

FIGURE 39

FIGURE 40

PASTIMES

National amusements are an enjoyable and revealing theme on money. What is important or collectively diverting enough to deserve a place? Well, the answer is some fairly unusual diversions. But as they used to say back in the sixties, different strokes for different folks.

FIGURE 41

Probably the most peculiar pastime represented, if you don't happen to live there and haven't grown up with the sport as a part of your life, like soccer and baseball elsewhere, is the traditional game depicted on this note from Afghanistan. It's wildly popular in surrounding central Asian countries as well, particularly Kyrgyzstan, where it ranks as the national sport. The image doesn't quite do it justice. Think polo. Then, instead of ball, think *dead goat carcass*. Like Jack Paar, I kid you not.

FIGURE 42

What do they do for amusement in Iceland during those dark, endless, howlingly cold winters? Like good sensible people, they gather around a warm fire and *read*. The group here is listening to a reading of one of the *Sagas*, those medieval Viking tales so filled with blood and adventure, that easily make the imagination soar when the weather outside is frightful. Icelanders are so devoted to reading that they boast two firsts: the highest literacy rate of any country in the world, and the most bookstores per capita.

FIGURE 43

Here's one of Mongolia's traditional pastimes—*moving*. Those oxen yoked in rows are transporting a yurt to its new, if temporary, home. A charming folk scene, if also a reminder that nomadic life may have its rewards, but it's a lot of work.

FIGURE 44

They have a communal activity on Fiji that's pleasing, useful, and a good way to cool off on hot days, which is every day there—getting together in shallow water to gang up on fish.

FIGURE 41

FIGURE 42

FIGURE 43

FIGURE 44

ECONOMY

If money makes the world go round, then commerce makes money go round—so it's no wonder that, after people, money-making endeavors constitute a major motif on world currencies. Such images are yet another way that countries define and identify themselves. As Camus pointed out, you are what you do. The different ways countries make their livings constitute an important part of national character. And of these, the two major areas of enterprise, agriculture and industry, are both represented on money in ways that are particular and individualized. Most of the notes featuring agricultural scenes—crops growing, people plowing or tending fields, harvests, farm machinery—come from developing nations, and their variety is as considerable as the countries themselves. One surprise is the number of *tractors* found on various currencies.

Industrial scenes are also abundant. Many depict what could be called The Romance of Industry—visual celebrations of technology on the march. Again, these are most often found on bills from developing or Third World countries, and their message is clear: *See, we've joined the Modern Age, too!* Along with the tractors, there are a surprising number of smokestack industries on world currencies, belching out dark, polluted clouds in the name of enterprise and progress. A scattering of high-tech images, space satellites, and radio telescopes find a place. As yet, no computers are to be found on money, but it's just a matter of time, no doubt—right after Bill Gates buys some nation that strikes his fancy. Images of transportation are also big. Jet airliners soaring over modern airports are pretty common, as are trains. But for some reason, one notable near-absence is trucks. Hardly any turn up, which seems an odd omission given their worldwide commercial importance. Probably the lowly truck doesn't seem charismatic enough to show. Ships, however, are another story entirely. Most *are* cool to look at, and a wide variety appear, from modest native and ancient craft to tall sailing ships and a few supertankers.

AGRICULTURE

BANCO CENTRAL DE COSTA RICA

5 5

ALEGORÍA, TEATRO NACIONAL. J.VILLA 1897

CINCO COLONES

FIGURE 1

FIGURE 1

Easily one of the most attractive bills ever issued, this 1989 Costa Rican note reproduces an 1857 painting that hangs in the elegant Teatro Nacional in the center of San José, the capital. On a festive market day, people gather on the beach to offer coffee and bananas for sale to a visiting ship. These two crops continue to be Costa Rica's two most important, accounting for nearly half the total value of all exports.

FIGURES 2 & 3

These next-door neighbors on the Gulf of Guinea in west-central Africa are rivals in the export of cocoa. They both put the crop on the backs of bills in 1991. For years Ghana was on top as the world's chief producer, but a variety of problems—prolonged unfavorable weather, old and diseased trees, shortages of pesticides—allowed the Ivory Coast to become #1 in 1978, and it remains so today. As figure 3 would indicate, Ivory Coast apparently has no shortage of pesticides. But Ghana's fighting back. It has begun making its own high-quality chocolate under the brand name Omanhene, with the motto "Eho Ye Na" ("It Is Rare"), to rave reviews from chocoholics all over the world.

FIGURE 4

For those who still only think "Idi Amin" when it comes to Uganda, it should be remembered that this is a green, fertile, and beautiful country east of Kenya that Winston Churchill once called "the pearl of Africa." Its economy is almost entirely agricultural, with 95 percent of its export earnings coming from produce, chiefly coffee—being picked on this five shilling note—cotton, tea, and sugar.

FIGURES 5 & 6

Both these bills, from the Central African state of Cameroon (figure 5) and Suriname (figure 6), on the northeastern shoulder of South America, show a significant local industry—logging their tropical forests. Not exactly PC. But it shouldn't be forgotten that a precolonial American squirrel heading south from present-day Cleveland, for instance, could have scampered from tree to tree all the way to the Ohio River without touching ground—it was forest all the way, not the endless cornfields and shopping malls now occupying the land. And England had chopped down all of its forests for firewood by the time of Queen Elizabeth I. Still, there's a certain sadness in these images—particularly the Suriname bill, which seems conflicted: on the left, an evocation of the rich beauty of the rainforest, starring a proud Jimmy Durante–beaked toucan—and on the right, guys with chainsaws, ruining his neighborhood.

FIGURE 7

Situated in that western bulge of Africa that would fit nicely into South America, Guinea is a largely agricultural nation, with 80 percent of its people employed in farming-related jobs. Bananas aren't its only important commercial crop—rice, tomatoes, strawberries, coconut palms, and citrus fruits are also grown—but, as can be seen here, they're certainly one of the most colorful.

FIGURE 2

FIGURE 3

FIGURE 4

FIGURE 5

FIGURE 6

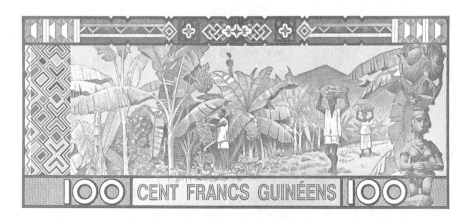

FIGURE 7

From Hand Cultivation
to Tractors

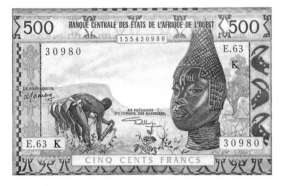

FIGURE 8A

FIGURE 8B

FIGURES 8A & 8B

The front and back of this 1959 all-agricultural bill from Senegal are a kind of visual Before and After, with traditional hand cultivation on the face and a modern bulldozer doubling as a tractor on the reverse.

FIGURES 9 & 10

In between tilling the soil by hand and powerful tractors, of course, came beasts of burden—oxen, in most parts of the world. In many places, they're either still pulling their weight, have only recently been retired in favor of machinery, or continue to work alongside their noisy replacements. The plowing image (figure 9), from Guinea in 1985, has a more contemporary, reportorial feel than does the painterly 1967 scene (figure 10) from Réunion, of oxen hitched to wagons overflowing with golden sugarcane—which, given how the farmers are dressed, seems definitely nostalgic. And gorgeous.

FIGURE 11

The contrivance shown on this 1991 bill from the tiny West African state of Benin is adorable—like a tractor from some innocent dream, just *barely* a machine. Hard to say what he's cultivating, though it's probably some ground plant such as cassava or yams, both of which are staple food crops in Benin.

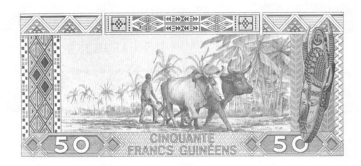

FIGURE 9

FIGURE 10

FIGURE 11

BANQUE DU MAROC
CINQ DIRHAMS
5 5

LES AUTEURS OU COMPLICES DE FALSIFICATION OU DE CONTREFAÇON DE BILLETS DE BANQUE SERONT PUNIS CONFORMÉMENT AUX LOIS ET ACTES EN VIGUEUR.

FIGURE 12

FIGURE 12

No question on this 1966 Moroccan bill—it's wheat harvesting time, using considerably more advanced equipment. The choice of this image may represent an assertion of national pride. Less than one-fifth of the Moroccan gross domestic product comes from agriculture. Barley and wheat are the main staples, but harvests vary greatly from year to year and frequently don't meet the domestic demand— which may make this image a state- ment of self-sufficiency: We can do it.

FIGURES 13, 14 & 15

The Wide, Wide World of Tractors: these are at work in Vietnam (figure 13), Bolivia (figure 14), and Ethiopia (figure 15). In Bolivia, cattle are still doing duty right alongside their successors. The note from Vietnam especially resonates beyond the image itself—a picture of a tranquil farm scene (with up-to-date machinery instead of water buffalo), peace at last in a country shredded by war for more than three decades.

FIGURE 13

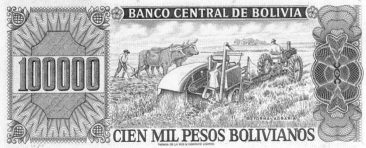

FIGURE 14

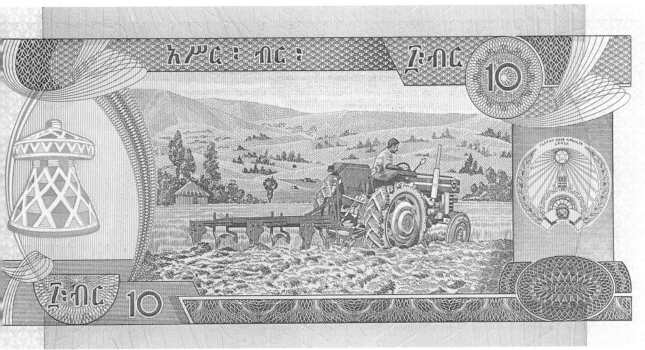

FIGURE 15

The Romance *of* Industry

FIGURE 16

Money celebrates national achievements, of which Science and Industry rank high. Both are beautifully encapsulated on this French bill from 1939, which *truly* romanticizes them—the thoughtful, handsome scientist bent over his microscope, with his phials and reference book, while out the window factories are busily producing whatever world-improving wonder he's just come up with. The arty interwoven blue border forms a sort of baroque picture frame—altogether, fit for hanging in the Louvre.

FIGURE 17

Starting in the late nineteenth century, and until very recently, the image of a smokestack industry has been a symbol of Progress, of the Modern Age. Today the smoke is an environmental no-no, and things like microchips and cell phones have replaced factories as signs of the times. This 1956 bill from Luxembourg sums up nearly a century of heavy industry ascendant. It's actually more than that—more of a national emblem. Beginning in the 1880s, little Luxembourg rapidly became the Pittsburgh of Europe. Exploiting its considerable iron ore reserves, Luxembourg produced steel in such abundance that as late as the 1960s it accounted for nearly 80 percent of the country's export income. No more. The ore began running out in the 1970s, steel prices slumped, and while manufacturing continues there, today Luxembourg makes most of its money from international banking and finance—and has the world's second-highest per capita income after Switzerland.

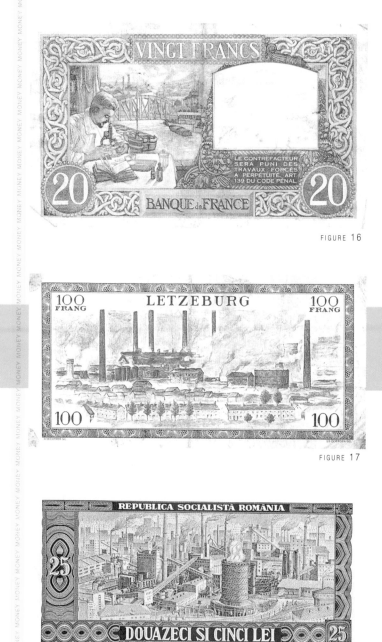

FIGURE 16

FIGURE 17

FIGURE 18

These three bills—from Romania in 1966 (figure 18), Bulgaria in 1974 (figure 19), and North Korea in 1978 (figure 20)—essentially tell the same story. All three countries were primarily agricultural before becoming part of the Communist bloc. Under socialism, they were catapulted into the Industrial Age—or such is the message here, in any case. The hyper-heavy metal scene on the Romanian note is perhaps more suggestive of Purgatory than Progress—or something out of Fritz Lang's *Metropolis*—but it's an accurate metaphor for the economy, now dominated by big industry, mining, and manufacturing, which together generate two-thirds of Romania's current income. Bulgaria today is also primarily an industrial nation, if somewhat less so than Romania. Electrical power plants, metallurgy, and chemical manufacture are the most important. Agriculture, Bulgaria's economic mainstay before World War II, counts for less than a fifth of its gross domestic product these days. Happily, nonsmoky tourism is becoming increasingly significant to the Bulgarian economy—inviting sweet afternoons on the Black Sea. Except for tourism, the same is true for North Korea, which has also shifted away from agriculture since World War II, and whose major industries, not counting crabby rhetoric, are now iron and steel, chemicals, machinery, and textiles.

FIGURE 21

How could Kuwait possibly *not* put a picture of an oil refinery on its currency? Virtually all of its money comes from the stuff—or income from overseas investments made with profits from its sale. It's given Kuwaitis one of the highest per capita incomes in the world. And at current production rates, they can keep it up for another 150 years.

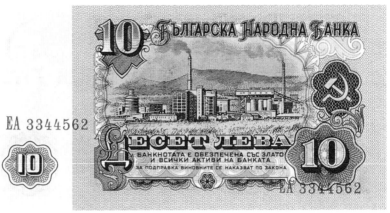

FIGURE 19

FIGURE 20

FIGURE 21

THE ROMANCE OF INDUSTRY

FIGURE 22

Ditto South Africa and mining. Diamonds and gold are its most famous minerals. South Africa is one of the world's largest diamond producers, and accounts for almost a third of the world's gold. But it is also #1 in the output of platinum and chromium, and produces a batch of other minerals including manganese, copper, silver, titanium, uranium, and beryllium, whatever that is.

FIGURES 23 & 24

Seen one hydroelectric dam, you've seen 'em all, no? No. These from Zaire (figure 23) and the Dominican Republic (figure 24) represent two quite different statements on the part of each country. For Zaire (now called the Democratic Republic of the Congo), it's a true national image. The Congo River system is extensive, and is being used to power serious hydroelectric dams. One on the lower Congo near the Inga Falls—shown here—completed in two stages, has a potential capacity of thirty million kilowatts. The country's overall potential hydroelectric capacity is 50 percent of all of Africa's, such that it now powers widespread domestic mining operations, and provides a surplus of electricity for export to Angola, Zambia, and Burundi. The Dominican Republic, on the other hand, is still chiefly agricultural, with sugar cane its staple, so the dam shown on its money has more to do with aspirations toward modernization than immediate economic significance.

FIGURE 22

FIGURE 23

FIGURE 24

FIGURE 25

Malaysia, as this 1996 bill fairly shouts, is soaring into the twenty-first century. Gone are smokestack industries. Say hello to space-age technology, in the form of the Kuala Lumpur telecommunications tower, and its attending satellite in orbit above. At 421 meters, the KL Tower is the tallest in Southeast Asia. The immediate support for the tower head is an innovative cultural statement, employing the traditional Islamic architectural form of the "muqarnas," a variation of the squinch, or corbeled arch. The pattern recurs in the tower shaft design and the touristic building at the base, paying homage to an archi-tectural idea a thousand years old.

FIGURE 26

Yes, this 1985 note from Tanzania celebrates . . . Tire-Making! Admittedly, it's an anomaly. Current notes feature more predictable (and aesthetically pleasing) images—giraffes and other wildlife, Mt. Kilimanjaro. Still, the tires are there. It's a statement of national pride, symbolic of the fact that Tanzania now manufactures things itself that formerly had to be imported. Along with the tires, new industries include food processing, beer brewing, textiles, cigarettes, batteries, and bottles. True, the country remains almost entirely agrarian—less than

10 percent of the gross domestic product comes from industry—but the bill says there's more to Tanzania than safaris and Hemingway's ghost.

FIGURE 27

And this 1976 Albanian bill is a paean to The Romance of . . . Scaffolding?? It would seem so. Relatively rich in resources, Albania is nonetheless the poorest country in Europe, due largely to colossal mismanagement by the centrist Communist government, which owned and ran everything—badly—until the late 1980s. It was enough to give Communism a bad name. Difficult to say what facet of national pride this image represents, but that rifle leaning against the pick probably gave pause to every regular Albanian through whose hands the bill passed.

FIGURE 28

The Gambia is a small, oblong country in west-central Africa that's essentially built around the river of the same name—three hundred miles long and fifteen to thirty miles wide—and is surrounded on three sides by Senegal. This 1991 image of its Abuko earth satellite station speaks of aspirations, since Gambia's economy is peanuts—literally. A classic monoculture, peanuts are its only cash crop, and peanut processing is its only significant industry.

FIGURE 26

FIGURE 27

FIGURE 28

FIGURE 25

TRAINS, PLANES & SHIPS

Images of transportation are another common motif on money. Trains, planes, and ships are the most popular—and all three turn up on the bright new Malaysian note (figure 29). Of these, trains are the least represented on current bills. This is probably because as symbols of progress and industrial might, their time has come and gone—except in places with high-speed rail. In the late nineteenth century, trains were *it* as emblems of the up-to-date, since their coming opened up vast stretches of land that had been previously unreachable—that is to say, commercially unusable because they were too hard to get to—and created such metropolises as Chicago almost singlehandedly. We also have trains to thank—or curse—for standardized time. Their rigid timetables created the idea. In pre-train Wisconsin, for instance, there were over fifty different local times; but with their arrival, we got our present simplified time zones, and the notion of being "on time" came to be.

Today jet airliners have become much trendier symbols of how progressive countries are. One image—of a jetliner taking off over an "international"-looking airport—has proved so imaginatively compelling that several currencies boast virtually identical versions.

The ships shown on money are the most visually appealing and engaging. They fall into three categories. First are traditional craft, often small and charming-looking, some dating back to prehistoric, or barely historic, times. These suggest an ongoing culture stretching back into the mists of time. Second, and most grand, are tall-masted sailing ships, chiefly from the Age of Exploration; these appear as reminders of great historical achievements. Finally, there are a few contemporary supertankers and such. But they're pretty clunky to look at, so there aren't very many of them.

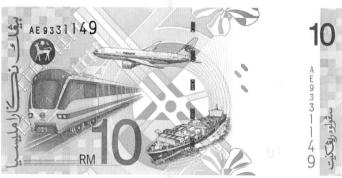

FIGURE 29

Trains

FIGURE 30

Trains remain important in Algeria. It's the second-largest country in Africa, and its vast landscape, a difficult if beautiful combination of mountains and Saharan desert, makes trains an even more essential means of transport than in places more physically forgiving—thus this bill from 1983.

FIGURE 31

Eritrea, located in the Horn of Africa along the Red Sea, separated from Ethiopia in 1993 after a war of independence nearly three decades long. Which is what this 1997 bill is about. It depicts a restored railway bridge over the Dogali River. Eritrea has only one major rail line, running from coastal Massawa inland to Akordat, and it was blasted into uselessness by the war. The image, then, speaks about rebuilding. Sadly, war between the two nations broke out again in spring of 2000.

FIGURE 32

Given the vintage look of the train and truck on this 1976 bill from Albania, it might still be the 1930s there. Certainly steam locomotives were long gone in most countries by the mid-70s. If this represents its latest models, the image is an unfortunate glimpse of how stunted Albania's growth has been.

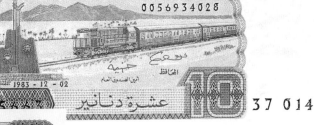

FIGURE 30

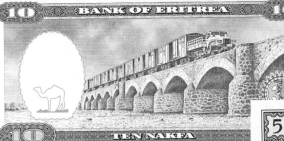

FIGURE 31

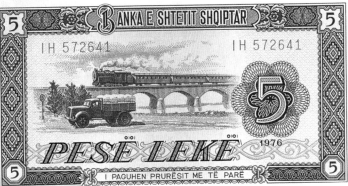

FIGURE 32

Planes

FIGURE 33

FIGURE 34

FIGURE 33

Gabon, on the west coast of central Africa, is *really* equatorial, averaging 150 inches of rain a year, with 75 percent of its territory still covered in rainforest. So difficult is it to maintain roads in the more or less continual downpour that Gabon relies heavily on air transport to move its main industrial product—manganese, shown here being loaded on a plane directly from a mine. But the accompanying traditional woodcarvings depicted on the bill, while lovely, give the suggestion of some sort of cargo cult.

FIGURE 34, 35, 36 & 37

These bills, from Singapore, 1977 (figure 34); Saudi Arabia, 1977 (figure 35); Indonesia, 1993 (figure 36); Kenya, 1980 (figure 37), announce these countries' technological parity and connection with the rest of the world, and they double as ads for their national airlines—since current geopolitical thinking goes that every country of significance has to have one. Air Singapore, especially, has reason to boast, since its food and service are routinely rated #1 in the world by discriminating freeloading travel writers.

FIGURE 35

SAUDI ARABIAN MONETARY AGENCY

ONE RIYAL

BANK INDONESIA

RAN068945

RAN068945

BANDAR UDARA INTERNASIONAL
SOEKARNO – HATTA

LIMA PULUH RIBU RUPIAH

50000

50000

FIGURE 36

FIFTY SHILLINGS

FIGURE 37

TRAINS, PLANES & SHIPS

Ships

FIGURE 38

FIGURE 39

FIGURE 38

The little sailing craft on this Peruvian bill are afloat on Lake Titicaca, which straddles the present border between Peru and Bolivia. At 12,500 feet, Titicaca is one of the highest lakes in the world. The boats are called *balsas*, which means raft or float in Spanish, and they've been made like this, from bundles of dried tortora reeds fastened together, since pre-Inca times. Remnants of an ancient indigenous people called the Uru still live on floating mats made from these reeds—communities that in their heyday were a sort of pre-Columbian Venice.

FIGURE 39

Putting this image on their money is downright sporting on the part of the Isle of Man, a ten-by-thirty-mile dot between Ireland and Scotland. It's a Viking ship, and the Isle of Man was routinely a victim, a regular stop on Viking marauding runs, which began about A.D. 800. Their primary

purpose was looting, pillaging, and slaughter—the Vikings, of course, were the seagoing Hells Angels of the Northland. The Isle of Man seems to have taken the exhortation about forgiving thine enemies to heart.

FIGURE 40

Originally home to a small neolithic population, Cyprus was settled by Greeks, starting around 1200 B.C., who arrived in ships similar to the one above. This particular boat is known as the "Kyrenia ship," a reconstruction of a vessel from 300 B.C., whose sunken remains were found about half a mile offshore from the northern coastal city of Kyrenia in 1969. It's currently on display there in a twelfth-century fortress.

FIGURE 41

A true beauty, this current bill is from the Republic of Maldives in the Indian Ocean, a chain of about thirteen hundred islands and cays scattered for five hundred miles

southwest of India. It's a sailor's paradise—a very *good* sailor, that is. The islands are small and low-lying, none rising more than six feet above sea level, and usually surrounded by barrier reefs; they are coral encrustations atop the remains of a submerged ancient mountain range, its final sigh. Fewer than twenty of the islands have populations over a thousand people, and most are uninhabited. Hundreds of unspoiled atolls, little more than pristine beaches and cocopalm groves, beckon like Paradise. But making a living in Eden can be hard. Beyond fishing and collecting coconuts—the centerpiece on this bill—there's little livelihood, and Maldives is one of the poorest countries in the world. This is doubly ironic, since cowrie shells (shown as part of the decorative border in the bill's lower left-hand corner) were the world's first international commodity-currency, and the Maldive Islands were their primary source.

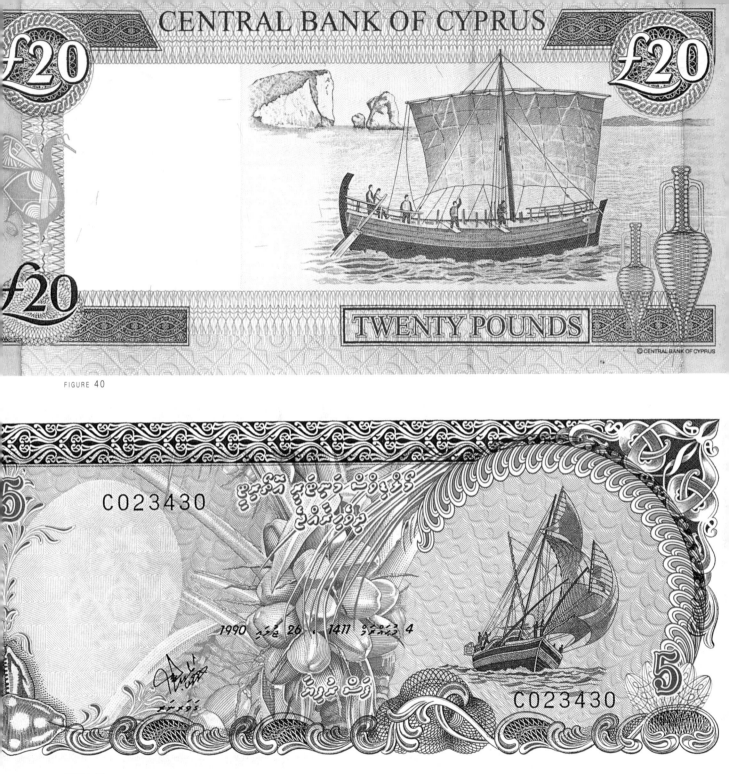

£20 £20

£20

TWENTY POUNDS

© CENTRAL BANK OF CYPRUS

FIGURE 40

C023430

1990 ٢٦ . 1411 ٤

C023430

5

FIGURE 41

The beginning of the Age of Exploration is credited to Columbus. His discoveries changed the world, making it at once larger and smaller. The impact of his voyages lingers on, remembered on currencies from many countries in both the Old World and New. After Queen Elizabeth, in fact, Columbus is the single figure most represented on money. Although Spain's Ferdinand and Isabella put up the cash for his first voyage, Italy also, and rightly, claims Columbus as a native son. These two Italian bills, from 1964 (figure 42) and 1971 (figure 43), both show him on their faces, but the backs here, depicting his ships, are nicer to look at. And the allegorical fish are terrific, especially the one which bears a strong resemblance to Donald Duck in a bad mood. The ships in figure 42 are the Niña and the Pinta, heading—or so Columbus believed and hoped—for China. To the end of his life, Columbus never did cop to the fact that he'd blundered into a New World instead. During the first voyage, the Santa Maria ran aground on Haiti, and was left behind, ravaged for its planks to reinforce the garrison established there. The return trip was horrendous. A violent storm separated the two remaining ships. Columbus, commanding the Niña, limped into harbor in the Azores, and then made his way home alone— as shown in the figure 43—to spread the news. And get funding for another trip.

Columbus was indebted to the achievements—and the passionate dreams of profitable worldwide sea trade—of the Portuguese. They've put a reminder of this on several of their current bills. Starting as early as 1415, Portuguese sailors had begun inching their way down the African coast. By 1430 they'd reached the Azores; Cape Verde in 1444; Sierra Leone by 1460. In 1482 Diogo Cão found the mouth of the Congo. Then in 1488, Bartolomeu Dias, whose brave little caravel is shown here on the back of the two thousand escudos note (figure 44), became the first European to round the Cape of Good Hope, realizing the prospect of a sea route via the Atlantic to the riches and spices of Asia. Dias sailed partway up the East African coast before heading for home. Vasco da Gama's expedition of 1497 was the first to make it all the way to India. The five thousand note here (figure 45) depicts, along with his ship, his encounter with the authorities in Calicut, who were less than thrilled by his arrival—largely because da Gama & Co. weren't Muslims, but also because the trading goods they'd brought, while successful with the Africans, seemed like tourist trash to the sophisticated Muslim merchants. A second, and more persuasive, expedition of thirteen ships with better goods—and considerably more firepower—was mounted in 1500 under the captainship of Pedro Alvares Cabral, whose vessel appears on the thousand escudos note here, along

with examples of Brazilian flora and fauna (figure 46). Why Brazil, if they were heading for India? Based on the experience of da Gama, whose expedition was becalmed in the Gulf of Guinea, Cabral sailed south and *westward* to avoid it, and ran into Brazil in so doing. This navigational maneuver came to be known as the "circle around Brazil." There's some question as to whether he actually got there, or simply to some offshore islands, but he's generally credited as Brazil's European discoverer. He only stayed ten days before heading for India. The fleet ran into terrible difficulty rounding the Cape of Good Hope. Four ships and all their crew—including Bartolomeu Dias—were lost. Cabral established a fortified trading post at Calicut, but soon afterward it was attacked by a large Muslim force. Cabral responded by cannonading the settlement, capturing ten ships, and executing everyone on board. His fleet then sailed south to a friendlier reception at Cochin, where he filled his six remaining ships with precious exotic goods, and headed home. Two ships were lost en route, but the expedition nevertheless proved the successful beginning of a trade route dominated by Portugal for a hundred years or more.

FIGURE 47

This from the Portuguese Territories in India seems an apt footnote. Intentionally or not, it depicts another longtime tradition in the history of ships at sea. *Hello, sailor!*

FIGURE 42

FIGURE 43

FIGURE 44

FIGURE 45

FIGURE 46

FIGURE 47

INTERNATIONAL ZOO

PAPA FIGO

Decreto - Lei Nº 42/96
S. TOMÉ e PRÍNCIPE.
22 de OUTUBRO de 1996.

CINCO MIL
DOBRAS

AA123 6883

BANCO

Welcome to The International Zoo. Representations of creatures are yet another way that countries express their special individuality on their money. And these constitute some of the most visually appealing bills of all. Images of birds are far and away the most common. Over two hundred different species turn up on an even greater number of notes. Many are the exotics indigenous to particular places; but since birds are international travelers, a number of the same species appear on money from countries thousands of miles apart. And not only the flashy, hey-look-how-pretty-*I*-am birds—a few countries are downhome and democratic enough to feature the more prosaic plain-lookers that are part of their everyday life.

After birds come animals that are signature species for various places. On African money, for instance, and not surprisingly, there's a whole safari's-worth of lions, elephants, giraffes, gorillas, rhinos, zebras, and so on. In Asia, it's mainly elephants and tigers. Favoring these goes back to the early days of coinage itself, when creatures symbolic of great power were often represented. A definite prejudice toward the warm-blooded exists on money, but nevertheless a few psychedelic tropical fish, colorful lizards, and the occasional turtle do put in an appearance. And a handful of bills even feature *bugs*!

The note at right (figure 1), from Madagascar, is quintessential. Madagascar has one of the most wonderfully weird ecologies in the world, and this note, with its lemur, great blue heron, tortoise, and butterfly, plus the botanical garden in the background, says that loud and proud.

BANKY FOIBEN'I MADAGASIKARA

500

DIMAN JATO ARIARY

FIGURE 1

BIRDS

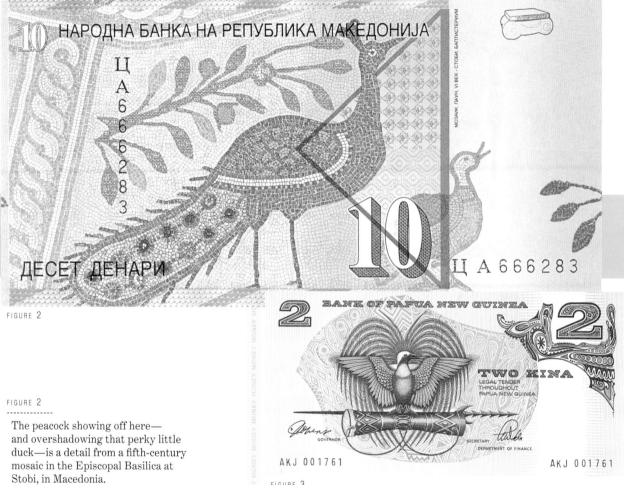

FIGURE 2

FIGURE 2

The peacock showing off here—
and overshadowing that perky little
duck—is a detail from a fifth-century
mosaic in the Episcopal Basilica at
Stobi, in Macedonia.

FIGURE 3

This bill from Papua New Guinea,
with its bird-of-paradise perched on
traditional objects, comes off almost
like a poster from the Department
of Tourism.

FIGURE 3

FIGURE 5

Though one would have to pluck it up out of its nest and check out its feet to know, this is a red-footed booby (*Sula sula rubripes*), not to be confused with the blue-footed boobies that so entranced Darwin with their quirky mating dance (they stomp their feet, raise their heads, and whistle!) on the Galapagos Islands. Far-ranging pelagic birds, boobies only come ashore to nest— and this one has wisely picked the Seychelles, in the Indian Ocean, one of the prettiest spots on earth— what better place if you have to be *on* earth for a while raising a family?

FIGURE 4

Speaking of mating dances, here are a couple of Lithuanian grey herons (*Ardea cinerea*) going at it. Guess which one's the male? Yes, the one acting ridiculous.

FIGURE 4

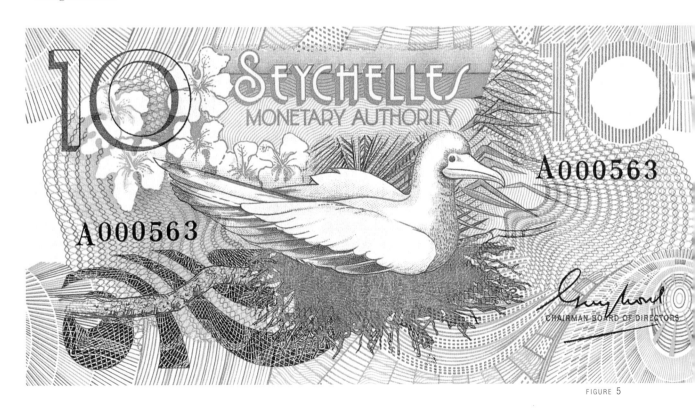

FIGURE 5

FIGURE 6

FIGURE 7

FIGURE 6

You'd think penguins, at least, living in the cold, remote southern reaches of the world, wouldn't be on any endangered lists. But this poor little guy from New Zealand, the yellow-eyed penguin (*Megadyptes antipodes*), is on the brink of extinction. The main population, on the southeast coast of New Zealand's South Island, numbers fewer than nine hundred and is heading downward. Loss of habitat and predators are doing them in. Known as *hohios* (the "noise shouters," for their piercing call) by the Maori, the yellow-eyeds are unusual penguins. They're not colonial nesters, preferring solitary nests in cool, shady forests to hanging out in crowds on beaches. They evolved with no natural enemies—they're possibly the most ancient of living penguins—and are now taking a beating from introduced species, particularly feral livestock. You can help by sending a donation to The Yellow-Eyed Penguin Trust, PO Box 5409, Dunedin, New Zealand. This has been an unpaid ecological announcement.

FIGURE 7

But enough cute, cuddly, and adorable. Here's a bird with *character*, looking serious and dignified in its mountain fastness. King of the Andes, the condor (*Vultur gryphus*), shown surveying its domain on this Colombian bill, is one of the largest flying birds (emus and ostriches don't count), weighing an average of twenty-two pounds and boasting a ten-foot wingspread. Noble creatures—no matter that they live on animal carrion and dead fish.

FIGURE 8

The tropics seem to have *all* the snazzy birds, even when they're not seventeen different colors with plumes a mile long. This blue-gray tanager (*Thraupis episcopus*) from Suriname, for instance. It's a modest little thing, but there's an understated elegance to its shades of silvery blue. By comparison, the brazen-colored North American scarlet tanager, for instance, looks like a guy in a bowling shirt.

FIGURE 9

Denmark gets the Quotidian Award for allotting space to these humble everyday little fellows on its money. No one else has given thought to the lowly house sparrow (*Passer domesticus*). Three *cheeps* for them!

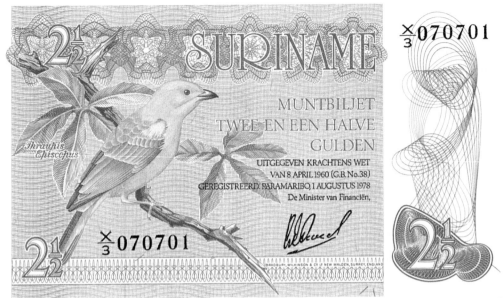

FIGURE 8

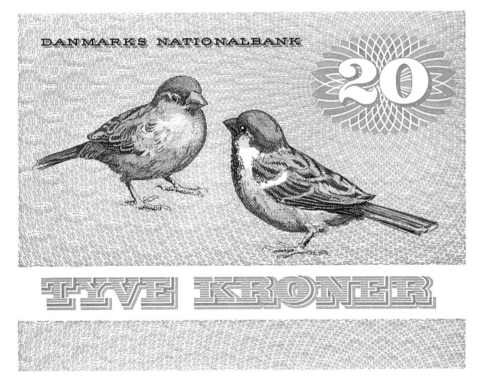

SERIE 1972

UDSTEDT I HENHOLD TIL
LOV AF 7. APRIL 1936.

FIGURE 9

AFRICAN SAFARI

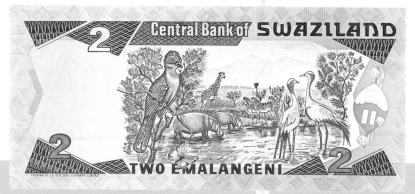

FIGURE 10

FIGURE 11

FIGURES 10 & 11

It's sundown at the waterhole on these two bills from Swaziland and Uganda. A small, landlocked, oblong country about a hundred miles long and eighty miles wide, surrounded by South Africa on three sides and Mozambique to the east, Swaziland has seen its wildlife diminish in recent years due to habitat destruction. Much of it exists today only in game preserves. The creatures here getting a drink are a purple-crested turaco perched prominently in the center, a couple of blue cranes, and a few of the usual suspects—hippos and giraffes. Uganda, also landlocked, lying east of Kenya, is much larger, with a more varied landscape that includes Lake Victoria, the world's second-largest freshwater lake after Lake Superior. That tall, spectacular bird standing at the left is a black-crowned crane. The antelope in the middle is a Ugandan kob, a water-loving species—of which there is plenty in Uganda.

FIGURES 12, 13 & 14

These current bills from South Africa make up their own monetary safari. Culturally significant is the fact that these magnificent beasts are on the *faces* of the notes. Most images of wildlife on money are relegated to the backs, with the fronts reserved for portraits of earth-shaking heads of government, living or dead. These are *much* more pleasing—particularly the grouchy-looking purple cape buffalo on the hundred rand note.

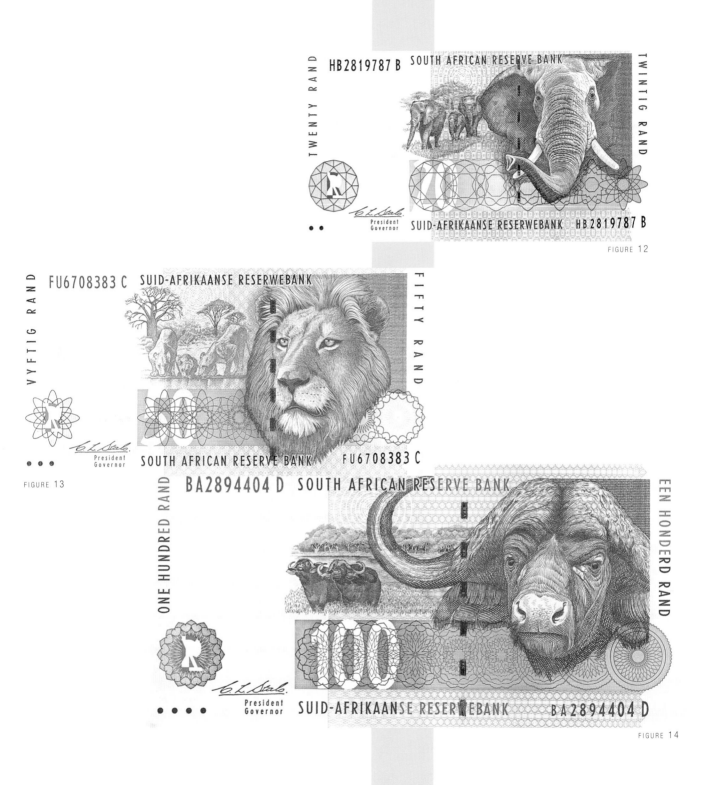

FIGURE 12

FIGURE 13

FIGURE 14

FIGURE 16

FIGURE 15

FIGURE 15

FIGURE 15

No wonder Dian Fossey fell in love with her gorillas in the mist—as did poor Anthony Hopkins in the 1999 movie *Instinct*. This forest family grouping from Zaire in 1991 seems soulful and serene. Gorillas are the closest living relative to humans except for chimpanzees. These are mountain gorillas, which are found near Lake Kivu. But they are an endangered species, or worse; only an estimated five hundred to a thousand individuals remain in the wild. Maybe that's why, here, they look a little sad.

FIGURE 16

Rwanda also borders Lake Kivu and is famous for its mountain gorillas; but it's more infamous for being the place where Dian Fossey was murdered in 1985 at her campsite as a result of her efforts to save the gorillas from poachers, and their habitat from the incursions of farmers. Better to put a herd of zebras on the money. Only 3 percent of Rwanda's land is still unspoiled forest. But within that 3 percent is Akagera National Park,

arguably the ecologically richest such preserve in Africa, famed in particular for its wetlands. It's a meeting-place of five distinct floras, and over fifty species of mammals call it home. But the civil war in Rwanda has taken its toll on wildlife, and returning refugees from Congo—some 600,000 of them—needing land are putting pressure on the government to open up parts of the reserve to settlement.

FIGURE 17

Namibia has two famous deserts—the Namib and the Kalahari—but in the north it's also got Etosha National Park, which at over eighty-five hundred square miles is one of the world's largest, and richest in so-called "big game" species, such as the red hartebeests here.

FIGURE 18

Someone certainly got inspired at the Kenya mint in 1974—blue lions!

FIGURE 19

Elephants, lions, zebras, and giraffes are practically a dime a dozen on African money, but Zambia can claim

to be the only country in the world whose currency depicts an *aardvark*. Great word—it means "earth pig" in Afrikaans—and great-looking creature, seeming a strange marriage of possum and pig. It's got a thirty-centimeter-long tongue for lapping up ants and termites, but it's not physiologically related to true anteaters. Aardvarks are *sui generis*.

FIGURE 20

As already mentioned, Madagascar has one of the most peculiar and complex ecologies on earth, largely because, like Australia, it's an island that was left in isolation to stew in its own evolutionary juices for millions of years. These guys—which seem like an unlikely amalgam of squirrel, cat, fox, and monkey—are lemurs, and they're found only on Madagascar and the nearby Comoros. They're some of the earliest human ancestors, but way down the scale from monkeys, having first evolved some fifty-eight million years ago. Three different species are shown here.

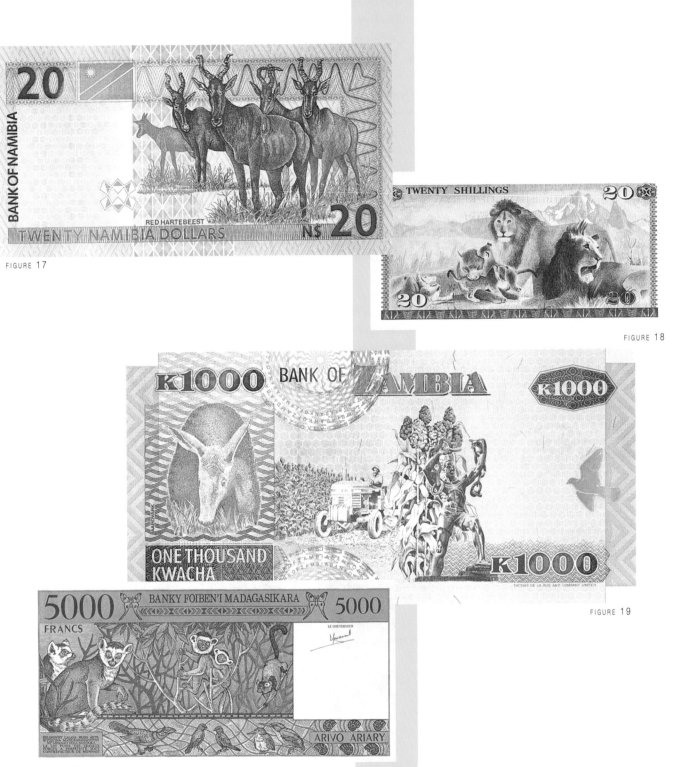

FIGURE 17

FIGURE 18

FIGURE 19

FIGURE 20

ASIA & ELSEWHERE

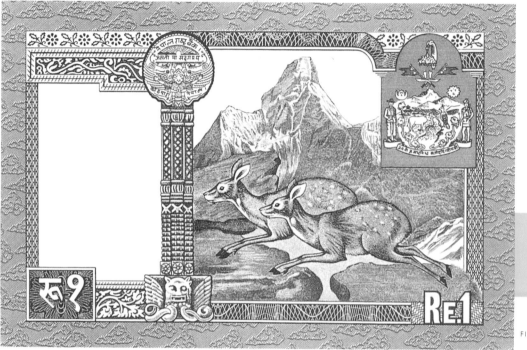

FIGURE 21

FIGURE 22

FIGURE 23

FIGURE 21

These shy, solitary, and graceful little fellows are musk deer, scampering across their dramatic domain high in the Himalayas. They're found in mountainous areas all through Asia, but these are in Nepal. The bill's design, employing Hindu decorative motifs, seems to catch them, frozen in mid-leap, as seen from the window of some ancient temple. No wonder they're running. The gland producing their musk is highly sought-after as a precious ingredient in perfumes and soaps.

FIGURE 22

The ferociously beautiful portrait of a Southeast Asian tiger here is also a political statement—though an ultimately unsuccessful one, as it happened. Images of powerful animals have been a mainstay of money since money began, as symbols of the power of the government issuing them. This one is from South Vietnam, and the date of issue was 1972. Nothing more need be said.

FIGURE 23

Should there be any doubt that wild boars are tough survivors, consider their range: They are forest natives all over Europe, North Africa, India, and China. Introduced to New Zealand and the United States, they've prospered there, too. Possibly because they're fast runners, good swimmers, have really nasty tusks, and will eat almost anything, quite happily. This specimen is from Papua New Guinea.

FIGURE 24

Like their threatened relatives the mountain gorillas, orangutans seem to be on their way out as creatures in the wild. Chief causes of their population decline? Logging of their habitat and hunting by humans. They are so intelligent that life in captivity, instead of up in the trees in their forest homes in Malaysia and Indonesia, must be like doing time in prison. Captives have proved remarkably adept at picking locks, though.

FIGURE 25

In Nepal, a predominantly Hindu nation, the cow is sacred to all of the faithful. This belief goes back to the Vedic period, beginning in the second millennium B.C., when cows became associated with certain deities and were accorded veneration. The cow is Nepal's national animal.

FIGURE 24

FIGURE 25

IT'S A COLD-BLOODED WORLD

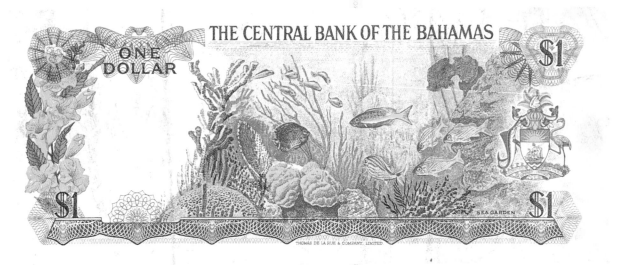

FIGURE 26

FIGURE 27

FIGURE 26
- - - - - - - - - - - - -

More Department of Tourism money, this coral reef scene from the Bahamas makes you want to pack your snorkeling gear and head for there to truly get *down* among the day-glo fish, sea fans, brain coral, and anemones; plus those barracuda, sting rays, and sharks . . . In the Bahamas, the best place to do it is off Andros Island, the largest of the seven hundred–plus in the archipelago, which has an offshore barrier reef that's one of the largest in the world and is known as "The Tongue of the Ocean."

FIGURE 27
- - - - - - - - - - - - -

Though they're six hundred miles west of the mainland, the Galapagos Islands belong to Ecuador. They take their name from the giant tortoise above; it was called a *galapagos* in old Spanish. Passing sailors found them so tasty that several of the approximately fifteen species were eaten into extinction during the nineteenth century. Darwin's visit during his world tour on *The Beagle* in 1835 solidified his ideas on natural selection —although he was more interested in the widely varying shapes of the beaks of finches on different islands there than in old *galapagos* himself.

FIGURE 28

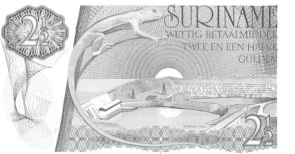

FIGURE 29

FIGURE 30

FIGURE 28

Caught here catching some rays on one of the Comoros Islands in the Indian Ocean, the green sea turtle is unusual. All other sea turtles come ashore only during breeding season, to dig holes in the sand and lay their eggs. But green sea turtles—found in warm coastal waters worldwide— like to hit the beach occasionally just for a little basking time.

FIGURES 29 & 30

Further proof, if any were needed, that the tropics have most of the hotshot members of almost any genera you'd care to name, are these lizards from Lithuania (figure 29) and Suriname (figure 30), respectively. The drab Lithuanians are in the family *Lacertidae*, but beyond that, don't ask. There are about 20 genera, and 150 species. Ditto the electric-green Suriname gecko. Choose one from the 82 genera and 650 species. Is there a herpetologist in the house?

Puntius nigrofasciatus

FIGURE 31A

Cethosia nietneri nietneri

CENTRAL BANK OF CEYLON.

ரூபியல் டெகெய்
இரண்டு ரூபாய்
Two Rupees

Murraya clontai

FIGURE 31B

Saving the cold-blooded best for last, this two-sided beauty from Sri Lanka is an easy Top Ten finalist for the loveliest single bill ever produced— true art on money.

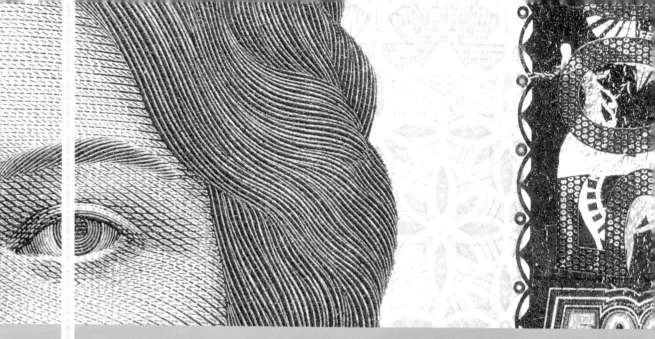

ODDS & ENDS

ARTFUL TENDER

Herewith, a gallery of special oddities. The imagery, design, impact—or some combination thereof—on certain bills defies categorization. Or in some cases, creates its own. Some are just plain pretty. Others are fascinating for reasons outside what appears on the note itself.

FIGURE 1

FIGURE 2

FIGURE 3

FIGURE 1

Czechoslovakia (now the Czech Republic) was the only country to depict a wedding on its money, and what a colorful event! The sunburst radiating behind the happy couple, a tree of life bearing fruit—how nicely symbolic—growing from what must be a Bible, the floral motif at the right . . . a lovely, optimistic note.

FIGURES 2 & 3

The design of quite a few bills worldwide is simply that—a design. Art for art's sake. These are from the Falkland Islands and Mauritania. Easy to tell which is which. The Falklands have a long historic connection with England—even if Argentina isn't very happy about it—and the bill here suggests a fine bit of fancy English lace (figure 2).

Mauritania's roots are Arabic—clearly expressed on the face of this current bill (figure 3). It's unusual because pure designs are usually relegated to the backs of bills; and it's *so* Arabic that only readers of Arabic can tell where it's from—or what it's worth. No numbers, either. Turning it over works, however. The country's name in western letters and the four hundred ouguiya denomination appear there.

General Zine al Abidine Ben Ali took power as President of Tunisia in 1987 after its longtime ruler, Habib Bourguiba, was declared mentally unfit and thrown out of office. That's the reason for this 1994 bill. But what's striking is the style of the art. It's got a certain unusual comic book quality to it that must have been deliberate, since the subsidiary motifs of the narrow city sidestreet on the face (figure 4A), and the intricate background design on the reverse (figure 4B), show no lack of careful artistic craft. To make the point more clear and easily understood— just as real comic books do? Could be.

Antiquities are yet another fairly common minor motif on money, and it's understandable that a few— quite a few, actually—would appear on Egyptian currency, since Egypt virtually *invented* antiquities enduring enough to last through the ages. Thus these stylized pyramids and the seated statue of Ramses II, lit by the rays of the sun—appropriate, of course, since Ramses II was the great initiator of the pyramid building program, and left statues of himself all over the place in case anyone might forget. Once again, however, what sets this bill apart is its *gestalt*. Considered as a visual unit, the bill is magnificent—a true Top Ten contender.

While we're in that part of the world, these are a couple of knockout design beauties also from Egypt. Characteristic local architecture is another common, if somewhat minor, motif on world money. Most compelling on these, however, is not only the look of the buildings, both handsome historic structures, but the effect of the overall designs.

FIGURE 4B

0505875 ‎ث/8

1994·11·7

FIGURE 4A

FIGURE 5

FIGURE 6

FIGURE 7

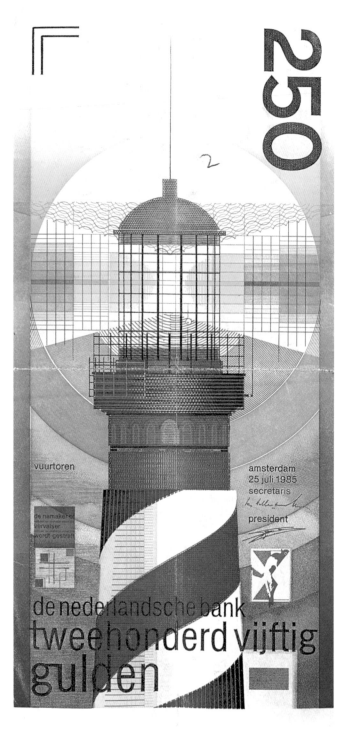

vuurtoren

amsterdam
25 juli 1985
secretaris

president

de nederlandsche bank
tweehonderd vijftig
gulden

FIGURE 8

FIGURE 8

Some designs, however, are of the *Doctor, my eyes!* variety. Smashing. Overload. This one's a 1985 note from the Netherlands. Drugs *are* legal there, right? This psychedelic lighthouse is great, though. The Netherlands are the hands-down winners when it comes to the bold use of colors and eye-grabbing modernist designs. Some representatives of the United States Mint ought to fly over, hit one of those *laissez-faire* Amsterdam cafes with them, kick back, and learn a thing or two.

FIGURE 9

This bill's fairly over-the-top, too. But it's this way primarily for reasons beyond the realm of pure aesthetics. In a word: Counterfeiters. As may have been noticed by now, the details on money in recent years have become increasingly complex in an almost logarithmic fashion, the designs ever wilder. The Swiss are usually thought of as a fairly conservative, stolid bunch. But you'd never know it from their money. This bill is the back of the one showing architect Le Corbusier with his head exploding. It is supposedly a representation of his "Modulor"—but only his mother would know. These images superimposed on images superimposed on images create a slightly bananas collage effect that's enough to make one dizzy. This complication exists mainly so that would-be counterfeiters will take one look and commence weeping. Too complicated even to have a go at it. There are hidden tricks as well: inks that only reveal themselves under infrared light, watermarks, special metallic threads woven into the paper. Most countries use such devices these days, but the Swiss, whose deep devotion to money is well known, are the leaders.

FIGURE 9

FIGURE 10

FIGURE 10

To end this gallery of artistic expressions, a sweet current curiosity from Belgium: a farmer taking a serene snooze with no one the wiser. We should all be so peaceful.

INFLATION

Hyperinflation is another factor influencing the look of money that's beyond aesthetic or cultural considerations. What happens when prices are going up as fast as a space launch? Well, first there's the incredible hardship it causes the people. But it hits the money as well. If it's taking ever greater amounts to buy things—that is to say, the currency is depreciating at a gallop—ever more zeroes have to be added to the bills in an attempt to keep up. One can see the suffering in this regard in the currencies of an unfortunate number of countries—among them Brazil, Bolivia, Peru, Venezuela, Nicaragua, Rwanda, Zaire, Croatia, the former Yugoslavia, and, sadly, others. In some cases the numbers on the bills become so embarrassingly high—the 500 billion note (figure 11A) from Yugoslavia being the apparent record—that a number of countries have adopted the expedient of simply dumping the name of the old currency, coming up with a new one, and starting over with nice, manageable 1s, 2s, 5s, etc. Peru, for instance, went from soles de oro in the 1960s, to intis in the 1980s, to nuevos soles in the early 1990s, which was still the currency's name at the time of writing.

FIGURES 11A & 11B

The crumbling of Yugoslavia that led to such tragedy is implied on the two bills here. In figure 11A, from 1993, a 500 billion dinara note—the number alone suggesting the wreckage occurring in the economy. The bill in figure 11B was issued just a year later, in 1994, after massive devaluation.

FIGURE 12

This Brazilian bill from 1981 appeared during a period of hyperinflation (lamentably ongoing). It's not a printer's error. Every denomination in the issue had these double images. Just a little *nuts*, no? And suggestive by accident of the economic turmoil occurring in Brazil at the time. Impossible even to hazard a guess as to why it seemed like a good idea. It's possible the designer had been part of a three-day poker marathon, and these were the result of his dreams afterward. They look like *playing cards*.

FIGURE 13

Moldova, a Balkan state, declared its independence from the Soviet Union in 1991—but not without difficulties that included border disputes, punitive tariffs on essential goods by Russia, and high inflation. The plain bill here from 1992, the republic's first issue, suggests the new country's straits. Calling the unit of currency the cupon seems an unintentional irony.

FIGURE 11A

FIGURE 11B

FIGURE 12

FIGURE 13

Almost all South American countries have suffered runaway hyperinflation in recent decades, and Bolivia, poor to begin with, has been one of the hardest hit. The three bills here are sad snapshots of the story. In figure 15, a proud-looking peasant woman appears on an attractive 100,000 peso note from 1984. But the next, for the same amount, was issued later in the same year. The change is practically shocking. It's not even designated as real money—it's a *cheque* (figure 14). The last note (figure 16) is from 1987, and represents an attempt at recycling an older, well-made bill. Notice the devaluation at the right: down from 10,000 pesos to *one centavo*.

FIGURE 14

FIGURE 15

FIGURE 16

THE EURO

The Euro is coming, the Euro is coming! After much thought, debate, and rancorous argument, the first European Union coins and notes are due to hit pockets and wallets in January 2002, for better or worse.

As of January 1999, eleven countries officially agreed to replace their individual currencies with the snappy new international Euro: Germany, France, Italy, Spain, the Netherlands, Belgium, Austria, Portugal, Finland, Ireland, and Luxembourg. Britain, Sweden, and Denmark decided not to get into the game. Greece didn't meet the Maastricht criteria and wasn't permitted to suit up, though it may be eligible before the end of the transition period in 2002.

All interbank commerce and stock exchange trade has been denominated in Euros since January 1999. So far the brave new currency has had a somewhat shaky start in international money markets. Soon it will be time for the arrival of the money itself. The official startup date is being called "E-Day." It remains to be seen whether or not this is a good omen. Certainly the Euro will make transactions among these countries less complicated. Those of us who are just lowly tourists, especially, will presumably appreciate its coming. No more changing money every time you cross a border, or recalibrating your head—trying to, at any rate.

But in terms of cultural expression and aesthetics, is the Euro an improvement over the colorful and idiosyncratic national currencies it's replacing? Look at the list of countries above. Then flip through these pages and check out the examples—a *tiny* sample—of the paper money produced by these countries over the last thirty or forty years. Then look at these new Euros (figures 17–20).

FIGURE 17

FIGURE 18

Is this an improvement? The answer, simply and obviously, is no.

In and of themselves, they're really quite attractive. But basically they're all the same. Think of the five-star restaurant of your dreams. Think of the wondrous delights listed on the menu. You probably have a favorite meal, and it's magnificent. Now think of this restaurant under new, streamlined management, *Maison d'Euro*. The menu has been stripped down to that single meal. Gone is the mouthwatering (and heart-stopping) array of choices. Would eating there in the future be as much of a delight? *Non.* So it is with the Euro.

To come up with the designs, contests and competitions were held over several years' time. Selecting the finalist must have been a real pain. Consider: the notes had to *say* Europe—but *all* of it. Couldn't be anything too particular, or anything that might miff the national pride of any participating country. Yes, we're talking lowest common denominator money here, that also had to be attractive—no easy task.

The final round was a little like the Euro Design Olympics. Three designers from each EU country were allowed to participate. Austria brought home the Gold. Designer Robert Kalina was the winner. The theme? As the official Euro website puts it: "The winning design is based on the theme 'Ages and Styles of Europe.' It represents seven centuries of European cultural heritage. The bills each contain three architectural elements: windows, gates and bridges. These elements also are a symbol of the openness and the cooperation in the European Union. Each value has its own dominating color."

So all that they could agree on as being quintessentially European—without offending anyone—were generic architectural details. Oh, well. The bills are at least fairly handsome.

But for fanciers of diversity and individual expression, the Euro seems no improvement, but rather the beginning of the end. Just as rare, beautiful, exotic plant and animal species are every minute going the way of the dodo and the passenger pigeon, so it may be with species of paper money.

In January 2000 there was a flurry of newspaper stories about Ecuador's money. The government had quite seriously proposed complete elimination of the national currency. What was to replace it? The U.S. dollar. Given the horrendous inflation Ecuador had been suffering, the dollar was considerably more popular there already. A few months earlier, Argentina, for the same reasons, had briefly proposed the same thing. If this can be seen as the beginning of a trend, by 2025 or so, say, all the countries in North, Central, and South America may be submitting entries in a contest to design the new, improved ... *Amera!* And then by 2050, the *Worldo* ...

Egad.

It seems time to enjoy and appreciate the wonderful variety of world paper money while we can.

FIGURE 19

FIGURE 20

Section II: UNITED STATES

Paper money is as American as Ronald McDonald.

In 1690, the Massachusetts Bay Colony was the first to produce government-backed paper money—nobody else had done so before in the history of western civilization. It has proved a historic, if often dubious, achievement.

The early American colonists suffered a wide range of hardships, and one was a chronic shortage of real money—or "specie," as hard cash was then known. Silver Spanish pesos, minted in Mexico, were far more common than the official British coins, but all were relatively scarce. Many domestic business transactions took place using a considerable variety of commodity-money—tobacco and corn chief among them—as well as the Indians' longtime staple, wampum.

This use of commodity-money had been an and unwieldy to move around, however fragrant. Various animal pelts were used too, with complex ratios of value. In New York in 1703, an official exchange rate listed one beaver pelt as worth five pecks of Indian corn, ten pounds of pork, a pint of shot, six knives, etc. Don't have a beaver? No problem. The same list valued two foxes, two woodchucks, four raccoons, one bear, one otter, or five pounds of feathers equal to one beaver pelt. And a moose hide was worth *two*. Not surprisingly, beer, wine, and liquor were also common money

COLONIAL CURRENCY

early and ongoing solution. It was commonly called "country pay." The Boston colony had been so strapped for cash that in 1635 a law was passed allowing musket balls to pass as farthings. Iron nails were so precious that abandoned houses were often burned down just for the nails—and in many places they were used as small change. People were permitted to pay their taxes throughout the colonies with bushels of wheat, rye, oats, peas, and Indian corn, each designated as worth a certain amount of real money. Barrels of beef and pork were also accepted, as were butter and cords of pine boards. Live cattle were used as well. If paying taxes seems like a pain now, imagine having to drive a herd of your money to town every April 15. Especially in the southern colonies, tobacco was an important commodity-money—specified legal tender in Virginia as early as 1619—bulky substitutes. As late as 1727, Massachusetts listed no fewer than twenty-five commodities as acceptable for tax payments, including whale bones at least six feet long and cast iron pots. One has to wonder what the taxman did with all of this stuff.

There were several reasons the colonists were so short on money and had to resort to these unhandy expedients. Most of the immigrant colonists came to America with little in their pockets to begin with—the chronically broke and indebted Pilgrims being the most famous example. They found no significant deposits of silver or gold from which they could produce their own coinage. Then there was the drastically unbalanced balance of trade with England. As we were all supposed to learn in school, the prevailing idea was that the colonies existed entirely for the economic benefit of the mother country. Trade with anyone else was

prohibited (though often more in theory than in practice). They were to provide raw materials, and England would send back manufactured goods—for which the colonists often had to pay artificially jacked-up prices, and had also to pay in specie. This meant that much of the real money in the colonies flowed straight to England, and didn't stay in circulation at home where it could stimulate business and markets. Also the colonists, in what seems to have continued as a genetic national trait, absolutely hated the idea of taxes. Who doesn't? Colonial governments were loath to impose them, no matter what the hardship, and those levied often proved almost impossible to collect. And finally, various pesky alarums and excursions kept coming up that required soldiers to fight, and somehow they had to be paid.

Printing paper money, even though it generally lost value faster than a new car going out the dealer's door, and always led to inflation, seemed the best answer. It was easy to do—too easy, unfortunately—and was a whole lot less complicated to deal with than trying to figure out how many musket balls, pounds of feathers, and jugs of whiskey together added up to the price of a new suit of clothes.

The British colonists weren't the only ones in North America with cash shortages.

One of the weirdest solutions to the problem took place in Canada in 1685. A French military garrison there was eight months late in receiving its regular shipment of coins to pay its soldiers, and the Governor, apparently an inventive lateral thinker, came up with a novel expedient. He gathered up all the playing cards in the settlement and had them divided into fourths, marking the pieces with denominations, putting an official stamp on them, and declaring them interim money. *That'll be two jacks, please.*

Massachusetts's go at issuing paper money also involved paying soldiers—continuing paper's historic association with the economic demands of war.

As usual, the political situation in Europe circa 1690 was a mess. Everybody had taken sides and was fighting everybody else, in a conflict now called The War of the Grand Alliance—but grand is hardly the word for the power-grabbing that was going on.

The ongoing rivalry of the Bourbons versus the Hapsburgs had flared up again, eventually involving practically every country and principality in Europe, over, essentially, who'd get to own Spain and its colonies when its ailing, mentally unsound, and heirless king died. The complicated conflict developed excrescences in India, Africa, and even the still, primeval forests of New England and Canada, where it was known as King William's War—the first of the French and Indian Wars—and prompted the Massachusetts Bay Colony to produce the first publicly issued, government-sponsored paper money.

In April 1690, British Commander Sir William Phips had led a foray into Canada from Boston, and had handily beaten the French in Acadia. On May 28, even before his return, the Massachusetts House of Deputies passed a bill for the "encouragement of volunteers for an expedition against Canada." The bill, in a fit of optimism, provided for paying the soldiers out of the "plunder taken from the enemy."

What's wrong with this picture? That's right—it assumed that the only possible outcome was that they would win, and bring home cartloads of loot.

Early in August, Phips left Boston harbor with thirty-four ships and more than two thousand men. The plan was to capture the fort at Quebec, which sat high atop a cliff, overlooking the St. Lawrence River, virtually impregnable. Phips and his men settled in for a siege. But the French

outlasted them, and inflicted enough damage that Phips and his wounded fleet limped back to Boston, their prolonged assault a failure.

The soldiers, not unreasonably, wanted their salaries. But the colony's treasury was bare, full of cobwebs. Word spread that the soldiers were planning to mutiny if they didn't get their money. Britain wouldn't help out, and the colonists not only hated the very idea of taxes, it would take too long to collect them to be of any use in this immediate volatile situation.

What to do?

Of course—print some paper money.

In December 1690, the Massachusetts General Court voted to issue seven hundred English pounds-worth of public paper currency. The official document announced that being decent upright folks, they want to pay all their debts in a timely manner, but can't at the moment because they're broke: "Withal considering the present poverty and calamities of the country, And (through scarcity of money) the want of adequate measure of Commerce whereby they are disadvantaged in making present payment as desired."

They're not just crying poor here. This goes to the heart of deep, long-lasting money issues dividing the colonies and Mother England that moiled and festered until the Revolution—and, indeed, were one of its main causes.

The colonists felt, justifiably, that England's tight money policies regarding them unduly inhibited their ability to do business both at home and internationally.

The economic bleat in this old document is a complaint that would continue and grow louder, until it became the shot heard round the world. Increasingly during the next century the colonies would turn to printing paper money as a solution to their cash problems—and Great Britain would increasingly resist.

Another intriguing aspect of this 1690 Massachusetts document is that they didn't quite realize that they were issuing paper money—or perhaps more accurately, weren't quite ready to admit it. A few paragraphs on, it says, "Every one of which Bills according to the sum therein expressed shall be of equal Value with money." And a little farther on, it says that so help them, cross their hearts, no more than seven hundred pounds of this paper will ever be put in circulation, that as soon as the Treasury is able, "any person having of said Bills in his Hands, may Accordingly return the same to the Treasurer, and shall receive the full sum thereof in Money."

Real money, you know, not this flaky paper stuff we're putting out.

FIGURE 1

FIGURE 2

The "art" of Massachusetts's first paper money was pretty minimalist (figure 1).

Across the top spread a squiggly design that might have been drawn by a terrifically talented four-year-old. Much of the bill was occupied by an official text notice saying, in part, that it would be "accepted by the Treasurer & receivers subordinate to him in all publick payments." Beneath that came the main "art"—the colony's seal, which featured an Indian, rendered in a decidedly down-home folk art style, probably drawn by the same four-year-old. He's wearing only a loincloth and is reminiscent of the guy on the popular European "Wildman" thaler, which may have been deliberate. He's holding a bow and arrow, and what looks at first glance like a long snake floating over his head is actually a cartoon balloon, in which he's saying, "Come over & help us"—a slogan that's ambiguous at best. Help whom? The colony? How? Or, since it's an Indian saying it, help *them*? Do what? Suffer even more at the hands of dour pietistic Europeans?

Sure, at first the Massachusetts government promised no more paper money, or whatever it was, but two months later they revised the law, uncapping the upper end of how much they could print. It was simply too tempting, and the need too great. By May 1691, the amount of paper was up to 40,000 pounds.

But by increments the paper money lost noticeable value in comparison to actual coinage. Inflation began right away. Sellers naturally preferred getting coins over paper, and gave a cash discount. Would you, as a colonist back then, rather have had a piece of this new-fangled paper, or a nice solid peso, piece of eight, or one of the attractive "pine-tree shillings" that had been produced by a Massachusetts mint since 1652 (figure 2)?

Most people preferred the pine-trees. Even a bent one was better than paper. The English were so peeved by the popularity of the pine-trees over their own official currency that they shut the mint down in 1684. The acute shortage of hard cash persisted in the colonies.

In most, as in Massachusetts, the usual immediate spur to issuing the paper was the expense of fighting some battle or other. The first paper money printed by eight of the original thirteen colonies was produced to pay for military actions.

Next after Massachusetts came South Carolina's in 1703, to fund a foray against Spanish-held St. Augustine. They printed some more in 1707 to improve Charleston's fortifications, followed by several other military-related issues.

In 1709 the costs of Queen Anne's War—which lasted from 1702 to 1713—also prompted New Hampshire, Connecticut, New York, and New Jersey to print their first paper money, all to pay for expeditions into Canada to protect the colonies' northern borders. Rhode Island followed in 1710. This particular expensive round of fighting ended with the Treaty of Utrecht in 1713, in which real estate all over Europe and the Americas changed hands, and it was decided—finally!—that France

was the official successor to Spain's unfortunate, childless King Charles II.

But if it isn't one thing, it's another. Until 1763 the colonists still had the French and Indians to contend with—and had to raise military forces that needed to be paid. North Carolina's first paper money came in 1713 to finance a war against the Tuscarora Indians. Virginia, the last colony to resort to paper, did so in 1755 at the onset of the *official* French & Indian War, fought primarily over control of the Ohio Valley.

Like the first Massachusetts issue, eighteenth-century colonial paper money wasn't much to look at. In many cases, the bills' fronts were almost entirely occupied by text, usually insisting that this flimsy piece of paper really is worth something,

FIGURE 3

folks. New York, for instance, became the third colony to print paper currency in 1709, and its initial notes had only a scribbly woodcut design above a long statement that began "This indented Bill . . . shall be in value equal to Money . . ." The back was blank.

Notice that they still weren't calling it actual money. And technically, it wasn't. Most of these early issues were designated "bills of credit." They were thought of as short-term public loans to the government, which paid them out to creditors—often soldiers—who could then use them for various purchases, thus putting them into circulation. At the same time the colony would usually authorize a tax equal to the amount of paper printed, the idea being that the paper would be used to pay the tax, which would put it out of circulation and everything would be dandy. But new issues kept overlapping the earlier ones, more and more paper went into circulation, and, *voilá*, dread inflation. The term "bills of credit," incidentally, is where the term "dollar bill" came from, an admission buried in the phrase that the government owes you real money for it, silver or gold—which was theoretically the case until 1972, when the United States finally abandoned all pretense about such convertibility and simply declared that this paper money is worth something *because we say so.*

Not only was this colonial currency barely money, it was unprepossessing. Generally printed in one color—black—it was also pretty small. A typical size was three by four inches. But many of the bills had a certain folk art charm. Most did have images on them, if simply rendered, and in the aggregate are a reminder of how pastoral America was then. What did they generally choose to put on their bills, after the obligatory coats of arms and written disclaimers? For the most part, *plants.* Herbs, grasses, ferns, leaves of common trees, and crops—wheat, tobacco, corn,

oats. Plants useful or pretty, or both, with home-spun names—sage, parsley, betony, maple, oak, elm. Images of nature's beauty and bounty. There is a sweet innocence to them. They are straightforward, four-square. One issued by Pennsylvania in 1773 is a true charmer, the incarnation of Jefferson's vision of agrarian America: a woodcut scene of peaceful, orderly farm fields, with dark storm clouds and rain passing to the left, a beaming sun revealing itself in a clear sky on the right, with a rainbow curving to touch the cultivated land. What an idyllic way to convey such a strong political message—since the receding ugly black storm has to be read as England, and the emergent sun as liberty on the rise. Directly beneath the scene, though, it bears a less serene reminder: "To Counterfeit *is* Death" (figure 3).

Parliament kept restricting or flat-out forbidding the colonists to print paper, but they kept wanting to do so. One early proponent was Benjamin Franklin (that he was a printer himself probably had nothing to do with it). In 1729, at the age of twenty-three, he published "A Modest Inquiry into the Nature and Necessity of Paper Currency," in which he made the case, citing four principal reasons. He started with the thesis that "a certain proportionate Quantity of Money" is necessary for trade—too much being no good, but too little even worse. He said scarce money causes high interest, making those who have capital more attracted to lending money out at interest than putting it to more useful purpose, such as investing in land or business ventures, which would help the general economy instead of simply creating individual profit through *un*useful usury. Franklin said, too, that "People will have little Heart to advance Money in Trade, when what they can get is scarce sufficient to purchase Necessaries, and supply their Families with Provision." This "Want of money" also keeps prices too low, he argued,

while "a Plentiful Currency will occasion the Trading Produce to bear a good Price." Further, it "discourages Labouring and Handicrafts Men (which are the chief Strength and Support of a People) from coming to settle"—because they can't make a decent living. Finally, "Want of Money in such a Country as ours, occasions a greater Consumption of English and European Goods"—while more in circulation would noticeably tilt the balance of trade toward the colonists' favor by encouraging people to produce more of the things they need themselves instead of importing them. He then listed the sorts of people who would naturally be against these ideas—those who are already wealthy, and, good old Ben, dread lawyers, who "will probably many of them be against a plentiful currency; because People in that Case will have less Occasion to run in Debt, and consequently less Occasion to go to Law and Sue one another for their debts." God love him. He closes by saying that any England in its right mind couldn't oppose paper money, since it "will be so great a Cause of advancing this Province in Trade and Riches, and increasing the Number of its People . . . I cannot think it the interest of England to oppose us in making as great a sum of Paper Money here, as we, who are the best Judges of our own Necessities, find convenient."

He apparently couldn't resist a little pre-Revolutionary dig at the end there: We know what's good for us better than you do.

Certainly he believed all this, deeply—he went to England in 1766 to plead the very same case, without success—but it should be noted that in 1731, two years after the publication of his "Modest Inquiry," Franklin's Philadelphia printing firm was awarded the contract to print Pennsylvania's third issue of paper currency, which it continued to do right up to the Revolution, and subsequently got the business of the Maryland,

FIGURE 4

New Jersey, and Delaware colonies as well. Nothing wrong with turning a little profit while doing the right thing, I guess.

Franklin also came up with the idea of putting a nature print on the backs of the bills. The first featured fern leaves. Figure 4 is a slightly later version from 1760, showing three common leaves, with that cheery reminder, "To Counterfeit Is DEATH," and a nice big ad for his printing company directly below.

To be fair to the English, the inflation caused by this currency was often so horrendous that it threatened to become a swirling paper tornado that would leave the rickety colonial economies in shattered heaps—and deprive England of their benefits.

An official exchange rate between the paper currency and the Spanish doubloon—the commonest and most desirable coin because of its uniform quality—was set, but it proved hopeless. In respect to English sterling, one Spanish dollar was legally worth 4s 6d. But individual colonies, in a bidding war to get them, were paying more than that. In Georgia, one went for 4s 8d, New England was giving 6s, and New York 8s—almost twice the theoretical established rate.

This good old-fashioned economic rivalry pushed inflation, but a greater culprit was the freewheeling overissue some colonies deliriously indulged in. If paper money had been whiskey, tiny Rhode Island proved itself the most rip-roaring drunk of all. Its first paper currency was issued in 1710, to pay expenses for its part in a successful British attack on the fort at Port Royal in Nova Scotia. Issue followed issue, and by 1750, the decades-long bender found its unfortunate citizens having to cough up over 150 Rhode Island paper shillings for one Spanish doubloon. By 1770, Rhode Island's currency was virtually worthless—the old saw about not being worth the paper it was printed on literally come true.

Through the mid-eighteenth century, Britain kept trying to dam up the paper flow. The harshest such measure came in 1764, with a parliamentary proclamation forbidding the use of paper money as legal tender in payment of debts.

While this money controversy bubbled like some long-simmering witch's brew, Parliament also began legislating a succession of other economic acts that frustrated and ultimately angered its colonial subjects to the point of rebellion. In each case, the money question exacerbated the colonial reaction, got them fuming and grinding their teeth far more than they otherwise might have, had there been an adequate, solid supply of money in circulation. For better and usually worse, money makes the world go round. And without trying to diminish the high ideals that brought about the Revolution, it can be argued that money—and the

issue of paper money especially—was as much a root cause as were lofty beliefs about individual liberty—since the series of increasingly intolerable English statutes were mainly hitting Americans in their wallets.

Where to begin? Britain's most longtime and deeply despised blood enemy was France. They're *still* bickering, though it's down to a battle of British beef versus French wine at the time of this writing. The countries were at war over one thing or another almost continuously from 1689 until 1815. They'd been at it on opposite sides in the seemingly endless War of Spanish Succession, as well as the 1740–1748 War of Austrian Succession. And then again in the Seven Years War of 1756–1763, which was pretty much a continuation of the previous one.

But in 1763, with the Treaty of Paris, the enemies took a short breather, marking the end of the French and Indian Wars in America. The treaty rearranged the world political map like so many Monopoly properties changing hands. In the long contention over North America, France had basically given up—for the moment.

Oddly enough, this removal of the French menace in North America was a contributing factor to the Revolution. The colonists began to feel safer, and to think that they no longer really needed Mother Britain hovering over them—especially when Mom seemed to be cranky, spanking them without cause, using the switch of annoying new Acts and Proclamations that were costing them money.

Starting in 1763, Britain began Acting out in earnest—passing a series of Acts, Declarations, and Bills regarding the colonies that led like legislative stairsteps to the American Revolution. As a Pennsylvania newspaper summed it up in 1776, "When all this black roll of impositions is view'd together, what a shocking series of partial, tyrannic oppression do they present." And expensive ones.

Certain results of the 1763 Treaty of Paris were unwanted by the colonists, affecting two sensitive places at once—their liberties and their pocketbooks. One was the disposition of "Western" lands, all that rich wilderness country beyond the eastern mountains. With the French threat eliminated, the colonists were eagerly anticipating the rewards of a westward expansion: new farmland, new towns requiring new businesses, profitable real estate ventures. Frontier capitalism on the march! But the Proclamation of 1763 set an arbitrary western settlement limit, ostensibly to defuse further territorial disputes with the Indians. In the colonists' eyes, the Proclamation was a quarantine, and they were correct. It was an attempt by Britain to keep them on the eastern seaboard, where Mom could keep an eye on them and make them behave.

At this time, too, Britain decided to establish a permanent garrison of ten thousand troops in North America. The colonists didn't like this idea one bit. There was the obvious reason—it would mean having a standing army around to keep them in line should they have any unfortunate notions about civil disobedience. It was something, they pointed out, that hadn't been the case even when the French controlled Canada and the west. Worse, England expected the colonists themselves to pay for this unwanted protection.

To raise the money, England passed the Revenue Act of 1764. Its preamble was out front: "That a revenue be raised in Your Majesty's dominions in America for defraying the expenses of defending, protecting and securing same." To achieve this, duties were raised on a variety of high-end imported goods that the more prosperous colonists loved, including the Madeira wine to which they were so devoted.

This legislation is also known as the Sugar Act of 1764, because of its stipulations regarding

the essential ingredient of that colonial economic pillar—rum. The Act actually lowered the theoretical but seldom paid duty on molasses imports that had been on the books since the Molasses Act of 1733. The earlier law had required the colonists to import molasses solely from British islands in the West Indies. But these couldn't come close to supplying the demand, while the outlawed French and Spanish islands could, and cheerfully did. As a result, smuggling had become an established, even decent, profession in the colonies by the time of the Sugar Act. As John C. Miller says in *Origins of the American Revolution*, "Contraband French molasses brought wealth to numerous men later distinguished in the Revolution. The origins of the Hancock family fortune, in particular, would not have borne scrutiny by customhouse officers." While the Sugar Act cut the duty by more than half, almost no one had been paying any duty in the first place, so it was no deal for the colonies. Rhode Island alone annually imported fourteen thousand hogsheads of contraband molasses from French and Spanish islands, on which no duty had been paid. Rhode Islanders especially howled about the Sugar Act, claiming that their trade with the non-English islands was the foundation of their entire economy.

Further, England was bent on actually enforcing this one. They stationed warships outside American harbors, particularly Boston's, waiting to nab malfeasants. And in a gesture that seemed to the colonists to be rubbing their noses in it, Writs of Assistance were also issued in Massachusetts—proclamations made by the Royal Governor permitting British officers to barge unannounced into any building, home, or business, at any time, to snoop around in search of smuggled goods. The smart from this one stung all the way down to the Constitution, in the form of the Fourth Amendment, prohibiting illegal search and seizure.

Especially in Boston, where administrators were based, these new policies put a serious dent in the usual freewheeling smuggling that had become a way of life—drastically cutting down both on profits and the availability of molasses—and also worsened the endemic colonial shortage of hard money, since the foreign West Indies, the mainstay of this illicit trade, had been the major source of coins.

The colonists took one more major financial hit in 1764, when England announced that they could no longer use paper money as legal tender. Paper money had been outlawed for such use in New England in 1751, and now it was verboten in all of them. Official debts, such as payment of these new duties, had to be in specie. And there was even less of it in circulation than usual, because quite apart from these new Acts, a postwar depression had begun to set in after the close of the French and Indian War. Trade was in a slump, and England was making it worse.

In the following year, Parliament had yet another really good money-making idea: the Stamp Act of 1765. As Samuel Eliot Morison points out in his excellent *Oxford History of the American People*, it "was the first direct, internal tax ever to be laid on the colonies by Parliament; indeed, the first tax of any sort other than customs duties. It was a heavy tax, bearing on all classes and sections in America, the more so because the specified sums had to be paid in sterling. This meant that, in terms of colonial currencies, the tax was increased between 33 and 100 percent."

It was also a royal pain. All sorts of things required an official stamp, from legal papers to playing cards, and every single copy of every newspaper.

But the Stamp Act was so immediately and roundly hated that it didn't last. Groups in all major cities along the seaboard, calling themselves

the "Sons of Liberty," orchestrated dramatic protests. In New York, on the November day the act went into effect, a mob sent the Lieutenant Governor scurrying for safety aboard a British warship, broke into the Governor's carriage house, destroying all his carriages, and then convinced the "stamp master" that burning all the stamped paper was the smartest thing he could do. Bostonians reacted by hanging the stamp man in effigy and then trashing his house, finding it so satisfying that they did the same to those of other officials, including the Governor's. In May 1765, a Stamp Act Congress met in New York City with representatives from nine colonies—the first such unified get-together over grievances against England—and drafted a document demanding that the Stamp Act be rescinded.

Parliament quickly realized how badly it had misjudged its willful colonial children on this one and decided the Stamp Act wasn't worth all the trouble it was causing. Repeal came just a year later, in 1766. But this blow to British sovereignty required at least some face-saving measure. So while repealing the Stamp Act, they also passed the Declaratory Act, which was little more than a bald assertion of power. What it declared was that Parliament had authority over the colonies "in all cases whatsoever," adding that they "are and ought to be" subject to British law and rule. The message was, *You win this one, but we're still in charge here.*

Americans were delighted by the Stamp Act's repeal, and generally ignored the Declaratory Act. When news of the repeal reached America, parties and celebrations effervesced everywhere, with raucous fireworks displays in Boston, heroic beer-drinking in New York taverns, and decorous fancy balls in Virginia. It seemed for a time that civil war within the British Empire—and most colonists thought of themselves as good British subjects, right up to the Revolution—had been averted.

Score one for the colonies.

But England still had a few Acts up its sleeve. Clever Charles Townshend, Chancellor of the Exchequer, thought he'd discovered a nice big loophole in colonial thinking about money matters. The chief argument against The Stamp Act had been that it was an internal tax the colonies hadn't voted to pass. All right, said Townshend, then we'll just set new import duties on all sorts of stuff, since you've never had any constitutional problems with them. The Townshend Act of 1767 was the Revenue Act revisited, but, significantly, on all sorts of essentials, not upscale luxuries. Items designated for duty included glass, paper, paint, lead, and tea, the famous tea.

Since it wasn't a tax, how could the Americans possibly object? From the other side of the Atlantic came the reply: Just watch us.

Soon the colonies had reached a general Nonimportation Agreement. Their answer to the Townshend duties was a wholesale boycott of English goods—*everything* British, not just what was on the list. "Buy American" became the motto of the day. Non-Import Associations sprang up everywhere. Homespun replaced English cloth as a patriotic fashion statement. Forgoing their usual spiffy graduation outfits made from imported yard-goods, Harvard and Princeton seniors showed up at commencement in homespun, and the programs were printed on paper locally made.

Americans were as hooked on tea as the English, but there was a movement, largely successful, to stop drinking it, and they began experimenting with homegrown brews made from local plants, including raspberry and blueberry, and especially one made from leaves of a low evergreen shrub that they called Labrador tea. Coffee drinking began to be a popular substitute. This boycott on tea lasted right up to the time of the Revolution, and is arguably the reason that Americans

today prefer to get their caffeine fixes from coffee far more than from tea. So Starbucks has pre-Revolutionary patriots to thank for its present ubiquity. Inventive Ben Franklin weighed in on behalf of drinkers who preferred stronger stuff. Rum was *the* preferred intoxicant in the colonies, but since it had to be made from imported molasses, he urged decent, hard-drinking Americans to switch to *whiskey*, which could be distilled from local produce, corn in particular. A Pennsylvania newspaper chirped about the advantages, both physical and moral, that would accrue, saying such a shift would produce "a more hardy and manly Race of People when our Constitutions are no longer jaundiced, nor our Juices vitiated by abominable West India Distillations." Sounds a little like General Jack D. Ripper in *Dr. Strangelove*, doesn't it?

The boycott caused considerable hardship, especially on merchants, even those who chose not to participate, since all payments going out to England had to be in hard cash. As the *Boston Weekly Newsletter* put it in 1768, "if the Silver already drawn from us by the new Duties was to be beat into thin Plates . . . it would entirely cover the main Road from this Town to the Borders of York Government."

There were widespread shortages—nails became so scarce that building came to a standstill—and prices soared. But the boycott worked. By 1769, British imports in Boston were down by nearly 50 percent, and in New York the figure was over 80 percent. In truth, it didn't do as much economic damage to England as the American patriots hoped and claimed, since new markets were opening up worldwide that offset the loss of American trade. But, just as the Stamp Act riots had, the boycotts really got Britain's attention.

Parliament gave in and repealed the Townshend Acts in 1770. All Townshend duties were removed, except one—on tea. This was left to stand, in part because it was bringing in an appreciable profit despite the boycott—not everyone was patriotic enough to give up the habit—but more because it was a point of honor, maintaining at least a token assertion of the sweeping power over the colonists that England had claimed in the Declaratory Act.

More coincidental than truly ironic, the Boston "Massacre" took place on the very day that the Townshend Acts were repealed, March 5, 1770. It was hardly a massacre—more of a brawl gone fatal. A ragtag mob began baiting a "lobster-back" customs officer by tossing insults and snowballs at him, twenty British troops were called out, flung rocks replaced the snowballs, a shot was fired—whether by accident or so ordered remains a question—followed by more. When, literally, the smoke cleared, three Bostonians were dead and two lay dying. Not exactly a massacre, nor, as patriot rhetoricians quickly claimed, a British plot. Hard-riding silversmith and artist Paul Revere contributed to the legend, if not the historical record, by producing a popular engraving called "The Bloody Massacre," depicting British soldiers in battle formation firing on peaceable, unsuspecting Bostonians.

But instead of cranking up revolutionary fervor, as the radical patriots hoped, the Boston Massacre proved to be a passing blip. The repeal of the Townshend Acts had a calming effect, largely because it accompanied a wave of prosperity that lasted for several years. Bad harvests in Europe created a profitable market for American grain, and England, finally, changed its money policy. Paper money was still forbidden, but for the first time in colonial history, British sterling was officially allowed to flow into America.

The Tea Act of 1773 finally put matters over the top. Ironically, it made tea cheaper in the

colonies than it had been for years. But it sparked the protests that led to the Boston Tea Party in December 1773—the event that put both sides into a swift escalation of disputes that led inevitably to full-blown war.

How could *cheaper* tea do this? By undercutting the smugglers.

The British East India Company, which imported most of the "official" tea that Britons and Americans drank, had, through spectacular mismanagement, dug itself a deep financial hole. The British government netted nearly half a million pounds sterling in duties from the company every year, income that would disappear if it went under, which is where it was rapidly heading. So Parliament voted to step in and bail it out from ruin. The Tea Act kept the threepence tax on tea brought to America, but allowed the East India Company, for the first time, to ship the tea directly, instead of bringing it to England first and selling it there at public auction, then to be shipped on to America at a higher price. This elimination of the middle-man would make their price for tea even lower than what the smugglers were asking.

As Morison mordantly remarks, "It was difficult to find a constitutional issue in this device to undercut the tea-runners; but the radicals were equal to it. They had all summer to think it over, to write articles about the 'illegal monopoly' given the great chartered company, and to write poems about the 'pestilential herb'. . . So, when the tea ships began to arrive in four continental ports in December 1773, the Sons of Liberty were ready."

Dressed up as Indians, with their faces corked, patriots boarded the three tea ships at anchor and dumped the cargo overboard. One group included John Hancock, a devoted revolutionary who also just happened to dabble in smuggling himself. Hundreds of spectators lined the docks to watch the show. The Revolution had begun.

In retaliation, Parliament went into fast-forward Act mode. It passed the Boston Port Act early in 1774. Its purpose was to shut down the port of Boston completely until the destroyed tea was paid for, and warships backed up the legislation. All Boston shipping ground to a dead halt. The Massachusetts Government Act quickly followed. It provided that government officials should no longer be elected locally, but rather appointed by the Crown—so that England would be certain to have team players in key posts. In June 1774 came the Quebec Act. This one was chiefly directed toward ensuring the rights of French Roman Catholics still in Canada, and bringing the former French colony of Quebec into the British Empire. As such it was a landmark instance of religious tolerance on the part of traditionally anti-Catholic England. But it also provided that the borders of Quebec—safely under British rule—be extended as far south as the Ohio River, and include all territory between the eastern mountains and the Mississippi River. No settlers from the thirteen colonies allowed. It was a legislative pincer, semi-circling the restive seaboard colonies like a vast initial parenthesis.

Issues of rights aside, this was another wallet-grabber.

Despite the 1763 law prohibiting settlement beyond the mountains, people were beginning to move there anyway, and real estate speculators had been marking out vast "developments" in this forbidden wilderness with an eye to the inevitable westward migration. One of the most ambitious projects, promoted by Benjamin Franklin and counting George Washington and Patrick Henry among its investors, was the Vandalia Company, which petitioned to pay the Crown ten thousand pounds for a ten million–acre tract beyond the Allegheny Mountains—a bargain at a thousand acres a pound—that they were proposing be made into a

"Fourteenth State" called Westsylvania. Another in the works, that would have occupied most of present Illinois and Wisconsin, was called Charlotiana.

But Westsylvania and Charlotiana were never to be part of the U.S. map. The Quebec Act burst these and smaller speculative bubbles, and the investors, including our revolutionary leaders, lost all the money they'd put into these real estate dreams. So it seems at least possible that outrage against The Quebec Act wasn't entirely over grand ideals being trampled upon. But it did have the effect of further uniting the colonies against England, since it affected the expansionist desires that were later sanctimoniously codified into "Manifest Destiny."

The Massachusetts Act, the Boston Port Bill, and the Quebec Act were collectively called the Coercive Acts by the colonists. They were mad as hell, and they weren't going to take it any more. On September 5, 1774, the first Continental Congress met in Philadelphia. Only Georgia didn't send representatives. The Congress drafted a strong document stating colonial rights—declaring, among other things, the colonies' "exclusive power" to make their own laws regarding domestic matters—listed all oppressive measures enacted since 1763, called for their nullification, and also voted to stop *all* trade with England, whatever the economic consequences. While they were meeting, speedy Paul Revere rode into town with news of the "Suffolk resolves" just passed in Massachusetts, pronouncing the Coercive Acts unconstitutional and voicing their refusal to abide by them. For all practical purposes, Massachusetts had declared its independence. Revere brought news, too, that British General Thomas Gage seemed to be getting battle-ready. The Congress quickly drafted an additional document stating that if the Brits tried anything funny in Massachusetts, they would *all* jump into the fray.

Patriot military buildup proceeded in earnest over the following winter. Both sides knew war was coming, the only question being when and where it would start. It turned into a genuine shooting war on April 18, 1775, with the Battle of Lexington and Concord. General Gage was on his way to Concord with eight hundred troops to confiscate a large cache of patriot munitions. But always-in-the-saddle Paul Revere saw that light in the North Church tower, charged around all night alerting one and all, and at dawn, someone in this raggedy army of farmers and yeomen fired that shot heard round the world. The American Revolution was officially on.

In May 1775, the Second Continental Congress convened. And what was one of the very first things they did? That's right—passed a resolution authorizing the printing of paper money! At last they could do what they wanted regarding this issue that had been driving them crazy for nearly a century. The Second Continental Congress knew what it was about when it made the authorization of paper one of its highest concerns. They couldn't have won the war without it.

The American Revolution was the first war in history to be financed almost entirely by paper money.

The initial issue of these "Continentals" bears the date May 10, 1775 (figure 5)—the very first day that the Second Continental Congress convened. The amount voted into circulation was $3 million, payable, as it says in the fine print, in "Three Spanish milled dollars, or the value thereof in Gold or Silver"—but it doesn't say *when*. This new government being cobbled together had no reserves of precious metal whatsoever. The resolutions called for a tax to cover the amount, but the tax hadn't even been passed yet, much less collected. They were operating on faith and printer's ink.

Notice too that they're calling themselves "The United Colonies." It's telling. Except for rabid

Sam Adams and a handful of others, the idea that they were colonial citizens of Britain didn't leave the majority of Americans, even its revolutionary leaders, quickly or easily; and a remnant of that thinking shows up in this designation. The legend "The United States" doesn't appear until several issues later, on an emission dated May 20, 1777. The earliest version of the American flag, in fact, first raised by John Paul Jones on the *Alfred* on December 3, 1775, had as part of its design, along with thirteen stripes symbolizing the united colonies, a Union Jack! The Stars and Stripes didn't appear until June 1777. Old ways die hard.

Telling too is the fact that the amounts are in dollars, not pounds and shillings. This was another world first. German thalers and Spanish silver dollars had been around for two centuries, but the United States-to-be was the first national government to adopt the dollar as an official unit of currency. Clearly, the Continental Congress picked up

on the dollar for patriotic reasons. Or, rather, solidly anti-British ones. The word had come into English via Scotland, which was never all that fond of its pugnacious neighbors to the south, and had that going for it. Also, because England was so stingy with its sterling, the silver Spanish dollar was far and away the most common coin circulating in America. So it was out with pounds, shillings, and pence.

The images on the Continentals are remarkable, poetic in their down-home way. The backs, as with most colonial paper money, usually depicted native plants: leaves of common trees, plus strawberry, mulberry, raspberry, ivy, filbert, buttercup, carrot, acanthus, ragweed, parsley, and sage; and others less well known now—such as henebit (currently so obscure it's not in the *OED* or any of six botanical dictionaries I checked), betony (an herb considered a curative for ailments of the head, also used as a tea substitute, and smoked in lieu of

FIGURE 5

tobacco), and burnet (a bushy perennial whose evergreen-like leaves have a cucumber flavor, and were a favorite ingredient in herb beer).

The faces carried a shifting gallery of images, which, along with the Latin mottoes accompanying them, provide powerful and sometimes poignant visual metaphors for the evolving American state of mind during the progress of the Revolution, a sort of running commentary—some of them intriguingly ambiguous.

The $3 bill, for instance (figure 5). It shows an eagle in a death-struggle with a heron. Hard to say who's winning. Normally you'd bet on the eagle. But the heron, while on the bottom, has pierced through the eagle's neck with its long, sharp bill. The Latin motto, EXITUS IN DUBIO EST, doesn't help. It translates as "The outcome is in doubt."

The $4 from the same issue bears an image of a wild boar, charging, I guess you'd say, full bore into an extended spear. Its Latin motto says AUT MORS AUT VITA DECORA, "Either death or an honorable life." So it would seem that the boar is America, the spear England, and the boar is determined to chew up the spear or die trying.

The $5 in this series (figure 7) is one of the most striking, and fairly mystifying at first glance. Benjamin Franklin explained the image's significance in a Pennsylvania newspaper, and he should have known, since he designed it himself. He wrote:

> We have a thorny bush, which a hand seems attempting to eradicate. The hand appears to bleed, as pricked by spines. The motto is, SUSTINE VEL ABSTINE; which may be rendered Bear with me, or let me alone; or thus, Either support or leave me. The bush I suppose to mean America, the bleeding hand Britain. Would to God that bleeding were stopt, the wounds of that hand healed, and its future operations directed by wisdom and equity; so shall the hawthorn flourish, and form an hedge around it, annoying with her thorns only its invading enemies.

The $30 bill shown in figure 6 features a nautical metaphor—two actually. At the left a strong wind churns great waves on the ocean, with the motto VI CONCITATE, "It assaults with a violent force." But the vignette to its right offers a gleam of optimism, a shining sun and ships on a calm sea, and CESANTE VENTO CONQUIESCEMUS—"When

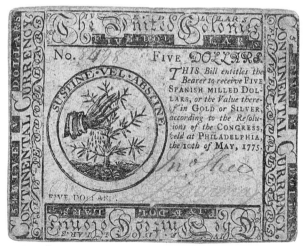

FIGURE 7

FIGURE 6

the wind subsides, we shall rest."

The next issue, for $3 million, appeared soon after, on November 19, 1775. Wartime expenses were burning up the money as fast as it came out. The $2 in this group of bills features a new image, of grain being threshed by hand with a flail. Its brave motto is TRIBULATIO DITAT, or, "It is enriched by affliction." The $6 shows a beaver gnawing at a tree, with the motto PRESERVANDO, or, "By persevering" (figures 8 & 9).

The aesthetic revealed in these images seems a visual embodiment of America's puritan heritage in the best sense—simple, direct, but resonating metaphysics as well. Together with the sentiments expressed in the Latin mottoes, this Continental currency is rather brave and stirring. The revolutionaries were, it should be remembered, taking on the world's most powerful empire. And doing so in part with this flimsy but courageous paper currency.

Continentals weren't the only paper money fueling the Revolution. Most of the colonies had intermittently been issuing their own paper at least since the 1750s. Once things began heating up in the spring of 1775, they *all* began to do so.

In many ways Massachusetts had taken the most heat from England over the years—and, to their credit, consistently provided the most cause. This was true regarding paper money. Britain had forbidden Massachusetts to print *any* since 1751. So, free at last, they began tooling up the presses weeks after the war broke out. The Battle of Lexington and Concord started April 18, 1775. On May 20, the Massachusetts legislature authorized the printing of 25,999 pounds in amounts ranging from six to twenty shillings—and not a moment too soon. Massachusetts was scrambling to raise an army, which would, they knew, be going into further battle at any time—and the soldiers had to be paid or many wouldn't fight, patriots or not.

Once more, it was Paul Revere to the rescue. He designed and printed the first Massachusetts paper currency issued in twenty-five years, again pulling a few all-nighters, working his brains out to get the job done fast enough to pay the soldiers before they walked off the job. The date on the notes is May 25, and Revere was stamping out the first sheets on June 3. In his haste and thrift, to make the needed plates, Revere mercilessly recycled, using the back of the copperplate on which he'd engraved his famous "Boston Massacre" print, and others, a Harvard College scene and several portraits. The commissioners had to hand-sign each

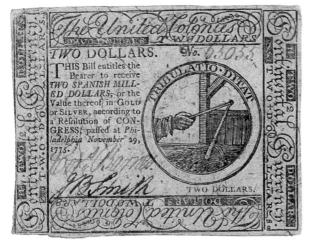

FIGURE 8

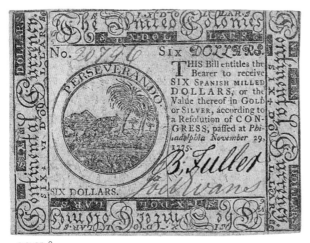

FIGURE 9

bill asserting its authenticity—39,251 altogether—but the first batch was in the soldiers' hands within days, and were doubtless in the pockets of many on June 16, at the Battle of Bunker Hill.

These "soldier notes," as they're known, exhibit a small irony. Beneath an inset vignette of acanthus leaves at the far left, they say "American Paper." But holding one of these bills up to the light reveals a watermark: a crown, with the initials G R, for "Georgius Rex," hated King George himself.

The Massachusetts government knew these bills would be slightly suspect. In its payment offer to the soldiers, they were given the option of taking twenty shillings in cash, or forty shillings' worth of the new paper. Hard choice, a financial test of faith.

Revere's printing of the second Massachusetts issue, coming in August 1775, is considerably more artistic. The front is again occupied by explanatory writing, but the back makes more of a visual statement.

These are known as the "Sword in Hand" bills (figure 10). The motto above says "Issued in defence of American Liberty," and the Latin trailing from the hilt of the sword translates as "By the sword one seeks peace under tranquil liberty." That piece of paper the Minuteman is holding is the Magna Carta, signed by King John in 1215, and traditionally considered the declaration of rights to English citizens—yet another indication of how tied, intellectually and psychologically, Americans were to Mother Britain, even as they were fighting to free themselves of her.

The war dragged on. More and more paper money was produced to pay for it.

In Continentals alone, the progress went:

May 10, 1775: $3 million.
November 29, 1775: $3 million.
February 17, 1776: $4 million.
May 9, 1776: $5 million.
July 22, 1776: $5 million.
November 2, 1776: $5 million.
February 26, 1777: $5 million.
May 20, 1777: $16,500,000.
April 11, 1778: $25 million.
September 26, 1778: $75,001,080.
January 14, 1779: $95,051,695.

That's a total of about $241 million over a five-year period. The individual states churned out another $210 million or so. The amounts issued each time jumped so fast, especially near the end, not only because the war was becoming increasingly expensive, but also because all this paper was creating something else new—hyperinflation. According to Glyn Davies, "By 1781 the value of Continental notes in terms of specie fell to one-hundredth of their nominal value, falling later to 1000 to 1." Denominations below $4 were

FIGURE 10

dropped in April 1778, and $20 and $40 notes added. In September of that year came the first $50 and $60 bills, and even Congress itself admitted that what they were printing wasn't worth face value, setting their worth at $4 Continental for $1 in specie.

By war's end, the paper coming out was worthless the moment it was printed. Worse. The paper and printing quite literally cost more than the money would actually buy. Washington's army shivered and semi-starved during their 1777–1778 winter at Valley Forge in part because so many farmers refused to accept Continentals for their goods and produce. The inflation in some of the colonies got so wildly out of control that there were recorded instances of creditors actually running way from debtors chasing after them waving drastically devalued paper bills, gleefully *begging* to pay off their debts. Barbershops papered their walls with the stuff—it was fairly good paper, anyway—and there was a small fad among waggish sailors to take a couple of basketfuls to tailors and have *suits* made out of them!

But the images and mottoes on these later Continental issues reveal a sense of gaining strength. The issue of September 26, 1778, shows a notable shift in both. The $50 in particular is historically significant (figure 11).

Yes, it's the first appearance of a major icon on American paper money, the thirteen-layered pyramid—although it wasn't quite finished yet. They were still building it, and hadn't yet plopped the weird glowing eye on top that completes the one that's been on the back of our current $1 since 1935. The Latin motto is PERENNIS, or, "Everlasting." The all-seeing eye came along on the $40 (figure 12) from the next issue of January 14, 1779, though on its own. They hadn't yet thought of putting these two visual ideas together.

This issue is the one that best shows their gathering strength. It was the first to bear the legend "United States of America." The $45 pictures beehives in a shed, with the motto SIC FLORET REPUBLICA—"Let the Republic flourish." On the face of the $55 a bright sun is emerging after a storm; the motto is POST NUBILA PHOEBUS, "After dark clouds comes the morning." On the back, the nature print is the meanest plant in the Revolutionary money salad—poison hemlock. The $60 also features hemlock on the back, with a globe suspended in space on the front and a line from Psalm 97, DEUS REGNAT EXULTET TERRA, "God

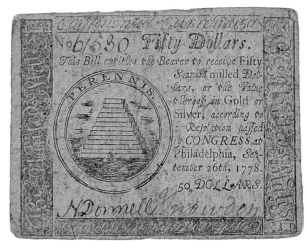

FIGURE 11

reigns, let the earth rejoice," which may be taken to mean that God has taken sides on this one (as He so often does in these scrapes). But the best, the *most* strong and proud, is on the $80, the highest and last denomination of the issue (figure 13).

The image is of a tall, sturdy, mature tree. The Latin motto, ET IN SECULA SECULORUM FLORESCEBIT, translates as: "And it will flourish through the ages."

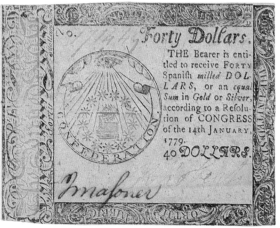

FIGURE 12

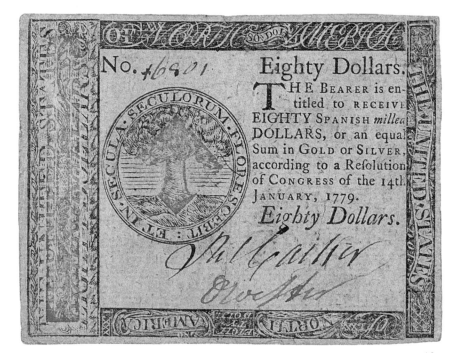

FIGURE 13

After the Revolution, the newly-formed United States government decided to get out and stay out of the paper money business, not returning to it until another desperate struggle in 1861. The post-Revolution paper debt had been dreadful. And when the country finally got around to organizing itself for good, dumping the weak Articles of Confederation, and constructing the muscular and resilient Constitution in their stead, paper money had no place. Alexander Hamilton, first Secretary of the Treasury and premier economist among the revolutionary leaders, led in the creation of a monetary system with the silver dollar as its base. The Coinage Act of 1792 also divided the dollar into cents—hundredths—and thus put American money on the decimal system, another world first. It provided, too, for the establishment of a mint in Philadelphia—the first official building constructed by the new United States. Hamilton handled the paper debt by initiating legislation that redeemed the worthless bills at a magnanimous 100 to 1. He wanted the federal government to absorb all individual state wartime debts as well. This got him a fight from states whose debt was small to begin with, or had already paid substantial portions. Virginia in particular fell into this category and was stamping its feet. So Hamilton worked out a deal. If Virginia went along with the program, it could enjoy the privilege and lasting status of having the nation's capital established on land inside its borders. Virginia said okay. So Washington, D.C. is where it is because of money.

REVOLUTION TO CIVIL WAR

Paper currency in America didn't simply disappear just because the federal government chose not to issue it. Far from it. Instead, individual banks in every state took over the happy burden. After the Revolution, banks multiplied like rabbits. There were four banks total in 1790. The number was up to twenty-nine by 1800, and ninety by 1811. But by 1816, five years later, 260 had their doors open for business, and most were issuing notes. The First and Second Banks of the United States, operating under charters from 1791 to 1811 and 1816 to 1836, respectively, put some brakes on the hot rod note-issuing, periodically forcing reality-checks on these banks by handing them significant amounts of their own notes to be redeemed in real money, as advertised on the bills. This kept them more honest than they might have liked, requiring that they have actual backing in the vaults for the paper they were issuing. The jump in numbers between 1811 and 1816 can be accounted for by the fact that the first United States Bank's charter ended in 1811, and a national mood of financial free enterprise forced its non-renewal. Banks issuing notes multiplied, which as always brought on inflation when inevitably their paper began circulating below par, and then the War of 1812 led to even more inflation; and so the pendulum swung, and in 1816 the Second Bank was chartered, though it was too late to forestall the financial turmoil that led to the Panic of 1819, one of our earliest depressions.

And Andrew Jackson hated banks more than rattlesnakes—stemming from his frontier upbringing, where banks to the poor debtor classes were the incarnation of Snively Whiplash. When the Second Bank's charter came up for renewal in 1836, during his second term as President, Jackson led the successful fight to have it shut down instead. After that, it seemed three guys with nine bucks among them could open a bank and issue notes. By 1840 the number of banks had hit 900. And in 1859, *Hodges Bank Notes of America* listed 9,916 different notes being issued by 1,365 different banks—which wasn't counting the estimated 5,400 different kinds of counterfeit bills also in circulation. By the start of the Civil War, when the federal government stepped in, and began issuing paper money again itself, over one third of all the paper money in circulation was counterfeit. So many of these note-issuing banks were fly-by-night operations, and/or went under without warning, rendering their money instantly worthless, that the bills from this period are known by collectors as "broken bank notes."

But they sure were colorful. The rampaging free enterprise that produced them also allowed a freedom of visual expression unparalleled since. The variety of imagery is as considerable as the institutions whose names were on them, since not only banks were getting in on the act. Any venture that wanted to give out loans, attract investors, or pay its employees could play the game, so the number turned out between 1830 and 1860 was far higher than the bank count suggests. And some of these bills, while they may have proved to be chump change, are great to look at, as well as being windows into early and mid-nineteenth-century America.

From about 1820, America was buzzing with new projects to 'civilize' all that land beyond the eastern mountains—especially those involving getting people and things from here to there: canals, toll roads or "turnpikes," railroads, and bridges.

The note shown in figure 1 was issued by a company building a bridge over the Delaware River at Lambertville, New Jersey, twenty miles north of Trenton. The Delaware marks the long north-south border between New Jersey and Pennsylvania, and is substantial enough that it

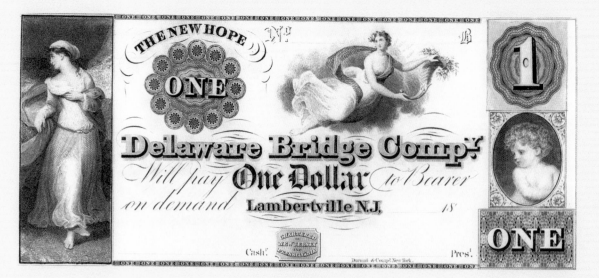

FIGURE 1

constituted an appreciable obstacle to western movement.

The imagery here may seem incongruous: fetching, diaphonously-clad damsels and one token cherub. It doesn't exactly say *Construction Zone— Bridge.*

Quite a few of the broken banknotes had this early pinup quality, such as figures 2 and 3, both from 1838.

Allegorical figures were common on money from the period, embodiments of the Romantic spirit and ethos burgeoning at the time. Both unclad allegorical ladies here no doubt represent Liberty. On the bill from the Tecumseh, Michigan, bank, that bird seemingly about to enfold Miss Liberty in his wings with a feathery embrace is, of course, our American Eagle. Probably meant as a metaphor for the American fondness for freedom, this cuddly patriotic scene also, if inadvertently, suggests the erotic Greek myth of Leda and the Swan. Naughty Tecumseh Bank! No wonder Tecumseh himself, at the right, is discreetly turned away, the great Indian leader probably shooting that arrow at white soldiers, just before he was

killed and his land taken away so enterprising new banks could be established there.

Certain of these bills reveal the jolts, both psychological and external, this flood of settlement and modern enterprise was having on the native peoples who had lived so long within the land, as part of it, unlike the Civilization on the March that they were encountering, which tries to live above the land, to get the better of it, rearrange and fix it according to its own notions. The bills were meant to finance "progress," but the images hint at what was being overrrun, and why we now have suburbs, shopping malls, and toxic waste dumps where woods and streams used to be.

The notes in figures 4–6, for instance, could

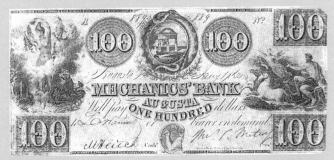

FIGURE 2

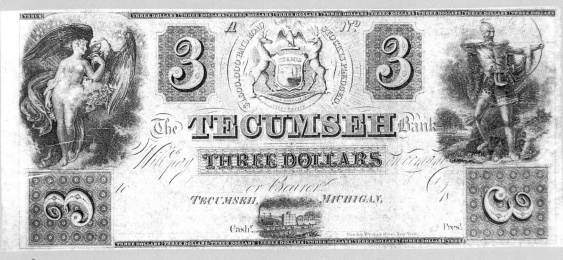

FIGURE 3

be titled "The Shock of the New."

The center vignette in figure 4 is perhaps one of the most honest renderings of American history ever. It shows the Indians meeting up with the Pilgrims for the first time. Their reaction? What else? Fear and loathing, cringing and terror. They weren't dumb.

The note from Briscoe, Harris & Co. (figure 5) features another seminude maiden, but here she's an Indian sitting on a rock observing some weird new *thing*, a huge steamship belching smoke, with a jaunty American flag flying from the stern. There's a look of quiet wonder on her face, as if this might just be an apparition, some legendary creature she's dreaming—or maybe hoping so, anyway. Just an unsettling nightmare that will pass, nothing more.

The central vignette in figure 6 has a sad majesty to it: the literal home of the brave being invaded by a long train chugging onward in the distance. Is the Indian in the lower right corner just resting, or also cringing? And while the effect was probably unintended, the upstanding white

American in the lower left, most likely the founder of the bank, seems an exemplification of the *worst* to come. He looks debauched, bilious, phlegmatic, like some villain out of Dickens who's been up all night drinking cheap whiskey, scheming to cheat decent folks of their last penny and foreclose on their hard-won frontier farms.

Cheerful milkmaids such as figure 7 were common in scenes depicting putatively idyllic farming life.

But other, newer, professions for women were also represented. The modern mills turning out textiles were an aspect of the growing change away from Jeffersonian agrarianism, and one that provided a new liberation for women and children, however dubious. They were now free to work in factories, as depicted in figure 8.

The wonderful—to look at, anyway—wildcat era of American paper money ended with the coming of the Civil War. It was out with the crazyquilt of currencies, and in with the sensible blanket of the Greenback Dollar. In terms of the art on U.S. money, it's been downhill ever since.

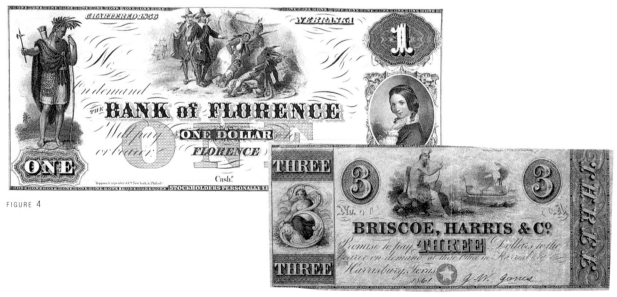

FIGURE 4

FIGURE 5

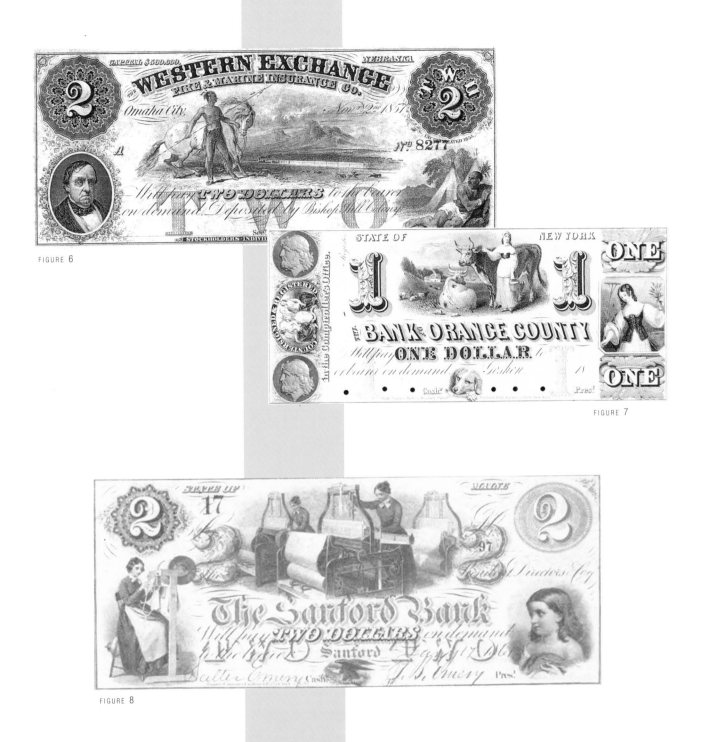

FIGURE 6

FIGURE 7

FIGURE 8

FIGURE 1

CIVIL WAR TO PRESENT

The Civil War brought profound changes to the United States, and one was the end of *laissez-faire* paper money. At the war's outbreak, with the firing on Fort Sumter in April 1861, hundreds of small banks and various enterprises were issuing their own paper— nearly ten thousand different notes by almost fourteen hundred banks alone—and more than a third of the bills in circulation were counterfeit. But the demands of the war quickly put an end to all that.

Money for the war effort—on both sides— was desperately needed, and needed in a hurry. The North quickly found itself close to bankruptcy. Early on it tried bond sales, but at first these proved sluggish. Two types of taxes were tried in 1861. One was on the states, levied according to population, not resources; poorer states felt it was unfair, and proved not really eager to pay. The other was a general income tax—the country's first—graded from 3 percent to a top of 10 percent (those were the

days!)—but even together the taxes didn't come close to raising the money needed. Tariffs were extended and raised, but because of the war, imports were down. Convertible payments in specie for banknotes were suspended, so that all the country's silver and gold could be concentrated in government hands and used to fund the war. It still wasn't enough.

Time to break out the printing presses.

As we've seen, the hyperinflation accompanying the flood of Continentals during the Revolution

had proved a major cautionary to the fledgling United States government. With the exception of issuing occasional treasury notes when it needed a little quick cash—during the War of 1812, for instance—the U.S. had gone out of the paper money business entirely. But now there was no choice.

By July and August 1861, the first of the so-called "demand notes"—of five, ten, and twenty dollar denominations—were authorized and soon began rolling off the presses, sixty million dollars created with a few strokes of a pen. Great trick. What could be "demanded" for them was a little unclear. The obligation read "The United States promise to pay the bearer X Dollars on demand." But additional specifics weren't forthcoming. Pay the bearer in what? There's no mention of gold or silver, or anything solid like that. Plainly a wartime expedient, it was the first "fiat money" ever produced by the United States, acceptable as money simply because the government said so. People were expected merely to use it, not ask questions, and keep the faith.

The obverse of the first $5 demand note (figure 1) showed a vignette of the statue standing atop the U.S. Capitol—Thomas Crawford's *Freedom*—and an oval portrait of Alexander Hamilton, who put together America's financial structure after the Revolution, and who presumably might have been found, given his sound-money policies, turning a few fast flips in his grave had he known about this money without any real metallic backing being circulated with his face on it. The reverse was purely a design, made up of dozens of tiny oval 5s, a couple of larger 5s on either side, and a big FIVE in the middle. They were in a hurry. The color was, yes, institutional *green*, variations of which have been the predominant color on almost all U.S. paper money ever since. The bills quickly earned their lasting nickname—*greenbacks*.

In February 1862, the Legal Tender Act authorized the printing of another $150 million. Additional issues through 1863 raised that amount to $450 million. These legal tender notes covered a range of denominations from $1 to $1000.

The portrait on the face of the $1 (figure 2) was that of someone whose name has pretty much dropped off the map today—Salmon P. Chase. He also turned up on the $10,000, the highest

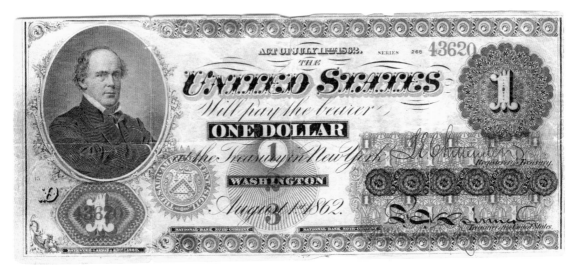

FIGURE 2

denomination ever in circulation, from 1918 (figure 22). Why him?, one might ask. Why not Washington, or one of the other Revolutionary heroes? But at the time, it was fitting. Chase was a former governor of Ohio and antislavery leader who'd run unsuccessfully against Lincoln for the party nomination in 1860. At the Chicago Convention he'd released his delegates on the third ballot to Lincoln, giving him the needed votes. As a reward, Lincoln had named Chase secretary of the Treasury. In that position, Chase had been the architect and guiding force in legislating this useful new funny money into existence. Thus the honor of appearing on the $1. In 1864 he was named to the Supreme Court, but he never gave up his hankering for office, running again for president, unsuccessfully, in 1864, 1868, and 1872.

With Chase directing traffic, the National Banking Acts of 1863 and 1864 were put through Congress. Their provisions effectively rendered the crazyquilt of state notes extinct. State notes weren't outlawed, but they were taxed to death. The Banking Acts set up a structure for the establishment of national banks in the various states; and these were permitted to issue uniform "National Bank notes," differing only in the names of the individual banks they carried—and were allowed to do so tax-free. The private state banks had to pay an issuing tax of 2 percent at first, which went up to 10 percent by 1866, and so by attrition their idiosyncratic notes gradually disappeared.

The imagery chosen for the First Charter of National Bank notes, which extended for twenty years beginning in 1863, is significant. These were the first government-issued bills depicting scenes from American history.

The United States was barely seventy-five years old when these bills first came out. Compared to the centuries of accumulated history across the Atlantic, America had little—of the kind that was then understood to be "history," at any rate, since the long traditions of native Americans, going back to paleolithic times, didn't count. Artists and writers had been complaining about this lack of tradition ever since the country began. Instead of tracing back generation after generation to knights in shining armor and beyond, in the prevailing Eurocentric view, if you went back just five or six generations in America, all you had were *woods*. Again and again, Mark Twain parodied the prevailing longing for a romantic past to write about—giving the soggy, sunken wreck of a ship in *Huckleberry Finn* the name *Sir Walter Scott*. Cobbling together an American cultural identity was a big problem in the first half of the nineteenth century. So the presence of these historical vignettes on the National Bank notes is meaningful. There were no historical scenes on Revolutionary money. These new notes were evidence that the nation had begun assembling the *story*, choosing emblematic moments, putting together the slide show of America's trip through history, however short, relatively speaking, the excursion.

Fifteen historical vignettes appear on the nine bills of the First Charter, some of which appear here (figures 3–7). One might expect them to have been put in chronological order, but they weren't. However, if that's done, this sequence emerges:

Columbus in sight of land

Columbus landing

DeSoto discovering the Mississippi in 1541

Sir Walter Raleigh in England, 1585, exhibiting corn and tobacco from America (figure 3)

The baptism of Pocahontas

Embarkation of the Pilgrims

The landing of the Pilgrims (figure 4)

Benjamin Franklin capturing electricity with
his kite

The Battle of Lexington, April 19, 1775 (figure 5)

The signing of The Declaration of
Independence

Washington crossing the Delaware (figure 6)

The surrender of General Burgoyne to General
Gates at Saratoga, October 17, 1777

Washington resigning his Commission

Commodore Oliver Perry leaving his flagship
during The Battle of Lake Erie,
September 10, 1813 (figure 7)

General Winfield Scott entering Mexico City in
1847 during the Mexican-American War

Interesting list. It's not exactly the slide show of American history that might be put together today. Most would still be keepers, but our own notions of signal moments are a bit different now. Unlikely that Pocahontas getting baptized would make a current Top Fifteen, for instance. Its presence says something about the greater importance of religion back then, and Christianity in particular—among our other accomplishments, the heathens were being brought out of darkness,

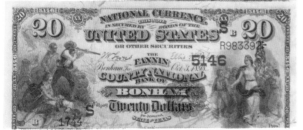

FIGURE 3

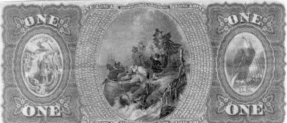

FIGURE 4

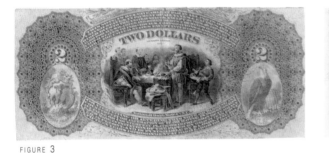

FIGURE 5

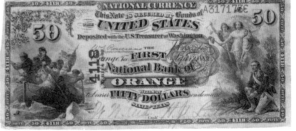

FIGURE 6

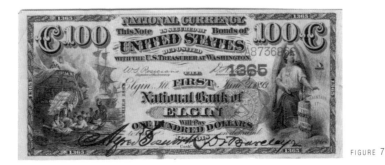

FIGURE 7

or such was the idea at the time. The Pilgrims weren't always as much a part of the psychohistoric landscape as they are now, but these bills show that this had begun by 1863—the year that, not so coincidentally, Lincoln first declared Thanksgiving to be a national holiday. Ben Franklin with his kite out in a thunderstorm is another non-obvious choice. But even then, the importance of electricity was beginning to be appreciated. Samuel Morse had come up with his telegraph around 1835, marking the start of the instant-communication glut we enjoy (??) today.

The choices of Revolutionary Moments show a better, and slightly different, understanding of that conflict than we have now. Lexington, Washington crossing the Delaware, and the signing of the Declaration of Independence, sure. But Burgoyne surrendering to Gates at Saratoga, probably not. The Revolution was a more recent memory in 1863, and it was remembered that this battle was the keystone to the Revolution's success, the one that broke England's back. And why Washington resigning his commission, instead of taking the oath of office as the first president? This choice, too, shows a closer and wiser reading of history than we have now. It was a precedent symbolic of democratic ideals. Great commanders of the past— and present and future—had, after wiping out the opposition, remained in charge and become Great Dictators. But not Washington. He resigned instead. Right after the war, there was a movement to have him named king; on becoming president, he had to discourage enthusiasm to call him "your Highness," insisting instead on plain "Mr. President." Showing him resigning his commission encapsulated an appreciation of his truly democratic impulses.

Today, Commander Perry and the Battle of Lake Erie wouldn't make the cut. The War of 1812 has faded to obscurity in our national imagination. And Winfield Scott marching into Mexico City is a definite no—the Mexican-American War is now more regarded as an imperialist national embarrassment than as a moment of national pride.

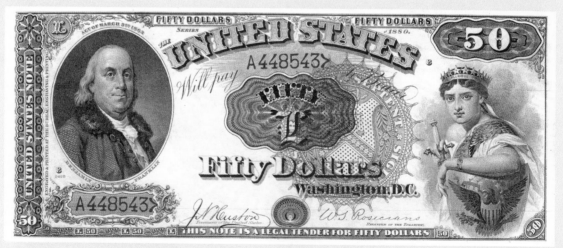

FIGURE 8

Allegories, too, were a major visual motif on American money from the Civil War until 1913, when the Federal Reserve was instituted, and began fulfilling its apparent mission to make United States currency as boring and dreary-looking as possible—of which more shortly.

Allegories on money are physical embodiments of a set of ideas or values. A few still reside in our cultural imagination—Justice, with her scales, fittingly blind; and Liberty, who, as we've seen, is usually missing a few of her clothes. But the concept covered considerably more ground in nineteenth-century America. Engravers came up with allegories for practically everything—and put them on money. Their presence speaks of a romanticism, even in the hard-headed, money-grabbing Gilded Age, made more romantic by the fact that most of these embodied abstract qualities seemed to take the form of attractive young women, often draped in revealing, classically inspired, gowns. Liberty, Victory, Justice, and Peace make the most frequent appearances.

On the $50 bill in figure 8, from 1880, the allegory is doing double duty—she's Liberty, dressed as Columbia, sporting a nifty tiara and shield. Loyalty, on a $50 issued in 1864, is sweet. She's shown—where else?—at home, standing by the hearth, wearing a modest white dress, patiently waiting for . . . whatever. She'll be there. Victory stands proudly on an 1874 $500, with a cannon and a few stray cannonballs at her feet—symbolic of the outcome of the Civil War. A little naughty, her Greek-style chiton is cut in a slash, revealing one bare breast; but she's Victory, and can get away with it. Sharing space on an 1901 $10 with Franklin and his kite is a figure of Liberty (figure 9), as a sort of Heavenly Lightning Rod. She's riding on the back of a soaring eagle, with one arm aloft, clutching a bolt of lightning. Electric lady!

But a number of these allegories aren't quite as familiar. Ever wondered what the embodiment of Architecture might look like, for instance? Few have. Who knew that Architecture was a woman? And a mother, to boot? But she is, on the face of an

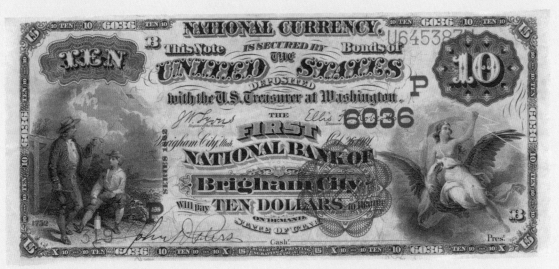

FIGURE 9

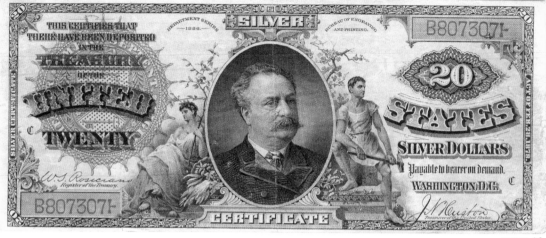

FIGURE 10

1869 $10 Legal Tender issue that she shares with an oval portrait of Abe Lincoln. She's shown standing, holding a draftsman's angle, slightly bent over a nude cherub at her feet, who's going over a scrolled set of plans discreetly spread out on his lap, as if he's reading them to her. It looks like she's measuring him for something—best not to contemplate what.

These gender decisions on the part of the Treasury Department designers are sometimes pretty odd. It seems non-predictable that the Spirit of the Navy would be female, for example, but it—or rather, she—is. But then all ships are "she's," so it probably figures. How about Transportation? Railroads, steamships, and such. Manly stuff, right? Wrong. Transportation's a woman, too.

The allegories aren't *all* female, however.

Science and Mechanics are both guys, appearing on an 1863 treasury note. They're shown sitting together on a beach, taking a break and talking something over; at their right is a vignette of naval ordnance—a couple of huge cannons—presumably the results of their efforts. Another allegorical fellow turns up on a $50 National Bank note from 1902. He's one of two figures in an engraving also featuring a steam locomotive roaring toward the viewer, and a steamship chugging along in the background. Its overall title was "Mechanics and Navigation." He's Mechanics again—typecasting, of course—and this time he's seated at the far left, by himself, holding a sledgehammer. As on the other bill, he seems to be on a coffee break. At the far right—as far away as possible to still be in the picture—is Navigation. And Navigation is a woman, pretty and bare-breasted. She seems to be staring a bit skeptically over at Mr. Mechanics. Altogether, if by accident, a fairly funny tableau, suggesting jokes about men getting lost and refusing to ask directions lest their masculine dignity be diminished. Possibly he can't find his way, won't ask, and she won't tell him until he does.

Industry, also male, is found in a distant twosome on a $20 silver certificate issued in 1886 (figure 10), along with the quite logically feminine Agriculture. In his tunic, holding a slightly smaller sledgehammer, he could be Mechanics' brother—or a very young Roddy McDowell trying out for *Julius Caesar*. He and fetching Agriculture aren't

interacting very well. They're separated by an oval portrait of that American legend, Daniel Manning, and have their heads turned away from each other, as if they've run out of things they have in common to talk about.

Perhaps it's just as well that this allegorical habit of mind has been abandoned on money. Imagine what the physical embodiment of Cyberspace might be. Or New Age.

Along with historical vignettes and allegories, the most noticeable visual trend on money from the Civil War through World War I was the ever-increasing appearance and predominance of politicians and bureaucrats—a tendency that gained speed and direction into the twentieth century until they have become *all* that's now seen on U.S. money.

Many of the choices during this period are proof, if ever it were needed, that fame can be fleeting. Some were heroes of the Civil War, and were obviously worth celebrating at the time, even if they haven't remained household names. Leaving out those, and others whose importance has remained enduring—or are still remembered, at any rate—here's a list, by no means complete, of some of the worthies who seemed, well, worthy of a place on U.S. currency through 1900:

Albert Gallatin
Robert Morris
William Windom
Edward Everett
Thomas A. Hendricks
Daniel Manning
William L. Marcy
Edwin Stanton
Hugh McCulloch
William P. Fessenden
John Sherman

History buffs and "Jeopardy" addicts will recognize some of these—*some.*

The most obscure here found their place on the money simply because they had been in charge, at one time or another, of running the Treasury. That's how Salmon P. Chase got his prominent spot as well. It's a form of institutional narcissism that's peculiarly American—few other countries have elevated bureaucrats to such iconic status.

Once the United States got the idea of producing paper currency, it pretty much went hog wild—not only in terms of how much was issued, particularly during the exigencies of the Civil War, but also in regard to the kinds of "financial instruments" that were created. We have so far mentioned demand notes, legal tender issues, National Bank notes, and silver certificates. Additional categories included compound interest treasury notes, interest bearing notes, refunding certificates, treasury or coin notes, and, most flamboyant of all, gold certificates.

Though surpassed by the deep, bitter political battles over Reconstruction policies, the so-called "Money Question" was a major issue in post–Civil War America. Paper money didn't simply sail onto the American scene without a struggle. More than some dry financial issue, it cut deep into the fabric of the country, with great social and even moral ramifications. Questions of how to "refund" the flood of wartime paper that had depreciated so considerably against real gold and silver created virulent feuds that took on the character of a class war. How much specie should be paid on the dollar? And how much paper should continue to be printed? The less monied wanted a higher refunding rate, because they were the ones most stuck with the depreciated greenbacks. They lobbied for "free silver" as well—wanting the government to mint, without change, as much silver into coinage as was brought to it, which, like printing more paper, would expand the money supply, always a better thing for the little guy. The controversy created

FIGURE 11

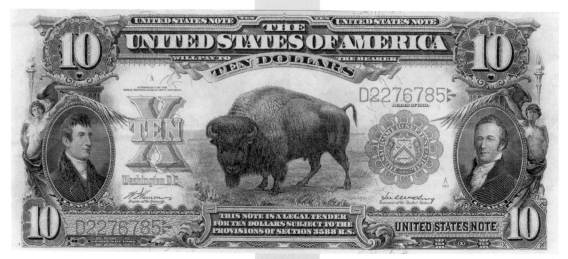

FIGURE 12

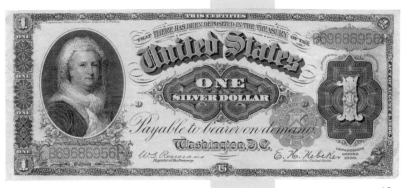

FIGURE 13

its own short-lived political party in the 1870s, the Greenbackers, which gained enough momentum to elect a few members to Congress.

What money standard should the country be on? Gold *and* silver? Just gold? Where did paper money fit in? The battle burned on into the 1890s, culminating in 1896 in the populist campaign of William Jennings Bryan. His peroration at the Democratic Convention in Chicago became legend: "You shall not press down on the brow of labor this crown of thorns, you shall not crucify mankind on a cross of gold." The gold standard was favored by the tight-money faction—read, generally, the rich. Bryan's opposition to the gold standard was virtually his entire platform. He lost. And the United States officially went on the gold standard in 1900.

One of the most colorful expressions of this gold-silver-paper question was gold certificates. There were six issues altogether between 1865 and 1900. The fourth series from 1882 was the first that reached general circulation. The "obligation," as it's known, stated that gold in the bill's dollar amount was on deposit in the Treasury, "repayable to the bearer on demand." Given the controversies of the time, gold certificates might be considered "designer money," for those waffling over the trustworthiness of greenbacks. See? It says right here—you can get actual solid gold for this piece of paper any time you want it! They only achieved a limited circulation, but were real wowie-zowie money to look at—especially the backs, which weren't the

usual drab green, but rather a bright golden-tinged *red*, and usually featured an eagle with its wings spread. Such as the $20 gold certificate from 1882 in figure 11, in which the eagle is shown with a lightning bolt grasped in its talons, commemorating the laying of the first Atlantic cable in 1858.

After 1900, U.S. money increasingly began getting duller and drearier, the range of imagery shrinking almost entirely to the realm of politicians and official buildings by 1920. But before that a number of bills were produced that were true artistic standouts.

The American Indian had been almost completely absent from the paper money issued during and after the Civil War, appearing only in bit parts, if at all. The lone exception—right down to the present—was the $5 silver certificate from 1899 (figure 14).

Plenty of room for bureaucrats, but this is the only actual, specific Indian ever to be a centerpiece on a bill. His name was Tatokainyanka, rendered in English as Running Antelope, and he was a member of the Oncpapa tribe of the Sioux Indians.

Similarly, non-allegorical women don't exist on American paper money. Except for Pocahontas, the only one to appear is Martha Washington, shown in figure 13 on a $1 silver certificate from 1886. The same portrait of her turns up on an 1896 note, alongside George. That's *it* for women. *One.* And her fame derived chiefly from having a famous spouse, of course. On money as elsewhere, women may have come a long way, baby, but they still have a long way to go.

The only buffalo to make an appearance on paper money is depicted in figure 12, sharing the stage on this 1901 legal tender issue with explorers Meriwether Lewis and William Clark—who saw millions of them on their celebrated expedition of 1804, which left St. Louis in May and made it to the mouth of the Columbia River by

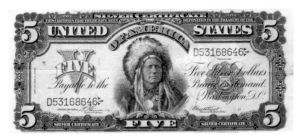

FIGURE 14

November 15, 1805. According to *Paper Money of the United States* by Arthur and Ira Friedberg, the standard collectors' reference, "There is a dispute over whether the bison is Black Diamond, the animal on the reverse of the Indian Head nickel, or Pablo, a bison which resided at the Washington Zoo." Controversies rage in numismatics.

The art of American money reached its apotheosis right around the beginning of the twentieth century—arguably, with the 1896 issue of three bills known as the Educational Series. With these it hit the top.

They are Allegory ascendant! The restrained richness and flow of the designs, the balance and texture, and attention to detail are superb. The $1 is known as "History Instructing Youth" (figure 15). Its subject is clear: History pointing out the principal sights of Washington, D.C.—the Washington Monument and the Capitol—to Youth, and presumably relating the stories behind each. The imposing book leaning open on the right is the Constitution; each of the wreaths forming the

border has the name of a great American inside. The attention to detail, especially, is splendid. Notice that the four 1s are all different, in a sort of competition for most elegant font. The allegorical message on the $2 (figure 16) isn't quite as obvious, but the design has a perfect symmetry, spreading in an arc, as if in invisible geometric rays, from the head of the standing central figure. Who are these graceful ladies and children? Bet you can't guess. They are "Science Presenting Steam and Electricity to Commerce and Manufacture." All right, so the message itself is a little foggy. Which kid is Steam, and which Electricity? And does the kneeling lady with her hand on her hip look more like Commerce or Manufacture to you? Her perky look somehow suggests that she's Commerce, and her friend on the left has a greater solidity that might somehow indicate that she's Manufacture, but it's hard to say. It's a great-looking bill in any case.

The $5 (figure 17), at first blush, looks just a little overwrought, a touch of Wagner and Beethoven in its highly dramatic (overdramatic?)

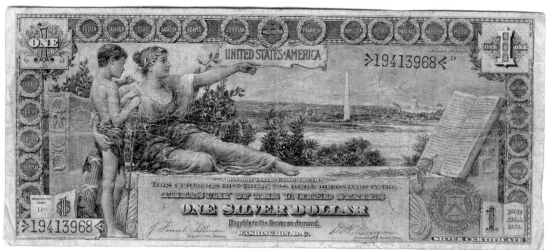

FIGURE 15

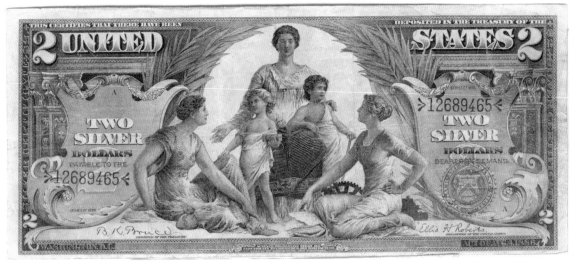

FIGURE 16

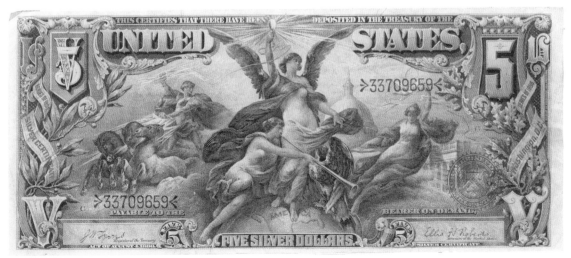

FIGURE 17

CIVIL WAR TO PRESENT

imagery. The subject here is a bit easier to guess. What's that the central figure is holding aloft in her right hand? It sure looks like an illuminated light bulb, doesn't it? Her eagle's wings spread wide suggest that's she's Victory, and altogether she makes a terrific-looking lamp! *Paper Money of the United States* describes the imagery on this bill as an "Allegorical group showing electricity as the dominant force in the world." A perfect choice for the times. By 1896, Edison's new bulbs were beginning to light up the world, use of the telephone was spreading, and Nikola Tesla had just built the world's first hydroelectric plant on the Niagara River above the Falls. The Age of Electricity had arrived.

The art on United States money began to go downhill after this.

The Federal Reserve System was established in 1913, in belated reaction to the financial panics of 1893 and 1907. The first truly national bank since the 1830s, it was created to better regulate the amount and flow of money for greater economic stability.

That stability—to a fault—has been reflected in the imagery on U.S. currency. In 1915 the first Federal Reserve notes appeared, followed by a second issue in 1918. At first they retained some of the visual variety of the issues preceding them, in some cases re-using earlier engravings of historical vignettes and allegorical scenes, as well as coming up with a few nifty new images reflective of the times.

World War I had dragged the United States onto the international stage, despite an isolationism that dated back to George Washington's admonishment to avoid foreign entanglements—violated, of course, by the Mexican and Spanish-American Wars, but a deep American trait nevertheless. The battleship on the 1918 note (figure 18) is a new symbol of power on money. More martial than a locomotive, it was a guns-and-steel assertion of

FIGURE 18

American strength, an emblem of the country's contribution to winning World War I.

On the $10 bill (figure 19), also from 1918, the times, they are a'changin'. The industrializing of America had been proceeding for decades, but its true arrival is celebrated here. No doubt the design was meant to suggest that the United States is both the breadbasket of the world and its new industrial pillar. But while we can't see the farmers' faces, the way they are aligned—the team of horses, too—suggests that they may be staring wistfully at this ugly new arrival coughing smoke.

In a burst of postwar fiscal exuberance, the 1918 issue also included the highest-denomination bill ever put into general circulation by the United States—the $10,000 bill (figure 22). Whose face seemed worthy of appearing on it? Salmon P. Chase. True, he was pretty much the father of federal paper money, but does that really make him important enough for the honor? It's a glaring example of the institutional narcissism evident on United States currency.

Coincident with the October 1929 stock market crash, and emblematic of the fall, Federal Reserve notes underwent a noticeable downsizing in that year. They were shrunk by twenty-five percent, to their current dimensions, and at the same time the roster of portraits and buildings was frozen, seemingly forever. There's been minor noodling with the designs over the years, but until the new redesigned bills started coming along a few years ago—still with the same old batch of guys, it should be noted—United States paper money had a dreary cryogenic quality for over sixty years.

And the money isn't just dull, it's fairly weird.

What must people from other countries think when they see that enigmatic, glowing eye, balanced on a pyramid on the back of the $1 bill? That the United States traces its origins back to visitors from outer space who purportedly founded Egypt?

FIGURE 19

The new $20s, $50s, and $100s aren't exactly an improvement. Same old buildings on the back, and the same old people. Their heads—well, they're too big. Hydrocephaly on money. They look like characters from the cable cartoon show South Park. And with the new, bigger print to go with them, they seem to have been designed by aging baby boomers for aging baby boomers—all of us who can no longer read without our glasses. MONEY: THE LARGE-PRINT EDITION (figures 20 & 21).

Actually, the weirdest picture is on the back of the $10 bill. Stare at it for a while sometime. In the first place, it's an etching of the U.S. Treasury Building—institutional narcissism in action again. But it's also the only current note with ordinary citizens on it. I count seven tiny figures standing in front of the imposing neoclassical Treasury Building, which is the star of the etching. Except for a single 1920s-vintage vehicle, the street in the foreground is empty.

I look at this and wonder: What does this say about America? There's an everyday bleakness to the scene, which might have been painted by Edward Hopper, or photographed by Walker Evans. There's a lonely, nondemocratic feeling to it that I'm sure no one ever intended—but it's there.

But for those of us in the United States, unlike the Netherlands's lovely fifty gulden sunflower note, at least this bleak scene will pay the bills.

FIGURE 20

FIGURE 21

FIGURE 22

INDEX